IMAGES
of America

MARYLAND'S OCEAN CITY BEACH PATROL

Robert M. Craig

ARCADIA
PUBLISHING

Published by Arcadia Publishing
Charleston, South Carolina

Printed in the United States of America

Library of Congress Control Number: 2019939528

For all general information, please contact Arcadia Publishing:
Telephone 843-853-2070
Fax 843-853-0044
E-mail sales@arcadiapublishing.com
For customer service and orders:
Toll-Free 1-888-313-2665

Visit us on the Internet at www.arcadiapublishing.com

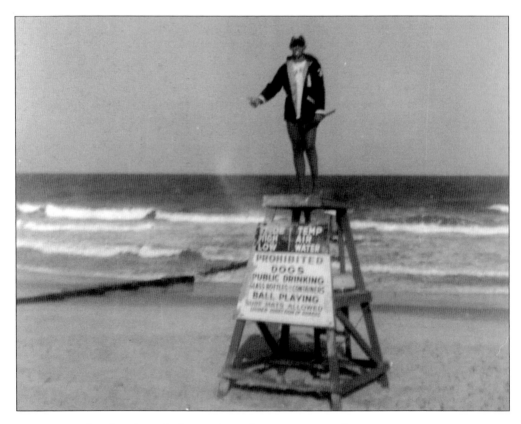

This book is dedicated to the memory of James R. Craig
(OCBP 1958–1962), Fifteenth Street lifeguard.

CONTENTS

ACKNOWLEDGMENTS

I am especially grateful to Kristin Joson, public education coordinator of the Ocean City Beach Patrol (OCBP), who suggested that I write a history of the beach patrol and who has made available the organization's newsletters, archived newspaper clippings, and photographs, many of which she took herself. Butch Arbin, current captain of the beach patrol, has lent his support and endorsement, and 2nd Lieutenant Ward Kovaks, as OCBP contact during the off-season, endured countless e-mail inquiries, helped me confirm dates and identify personnel, and responded to my numerous "fact-check" questions.

An illustrated book draws on the help of many people. Some are professional photographers, while others have taken snapshots to document events in their lives, preserving their images in photo albums as mementos. Many individuals who have memories of the beach patrol during periods when I was not an active member have aided me in confirming the accuracy of historical data, in identifying individuals in photographs, and in sharing personal experiences of their time as OCBP lifeguards. Much of this personal, institutional, and cultural memory is recorded within these pages. For the loan of photographs, for information unobtainable elsewhere, and for their willing support of this project, I am thankful to the following individuals, many of whom are alumni of the Ocean City Beach Patrol: Michaela M. Aitken, Butch Arbin, Charlie Austin, Robert J. Banach, Jennifer Bodine, Ellsworth Boyd, Henry Boyer, Wayne "Bru" Brubaker, Nick Burley, Rick Cawthern, Jack Chew, Chazz Chiamardas, Dan Cook, Jim Crowley, Charles "Chip" Dashiell, Jackie DeGroft, Stewart Dobson (editor, OC Today), John Dunnigan, Don Ellers, Harvey Evans, George Evering, Harrison Q. Fisher, Robert and Kathy Fisher (Fisher postcard collection), Chris Foster (Cape Gazette), Ed Fry, Julia Galen (Swimspire), Patricia Gerken (Delaware Historical Cultural Affairs), Steve Green (editor, The Dispatch), Lisa Helfert, Anne McGinnis Hillyer (OceanCity.com), Kevin Johnson, Kristin Joson, Ward Kovaks, Sean Lanahan, Skip Lee, Jim Leutze, Tom Lurie, Bunk Mann, Mark McCleskey, Latham "Beetle" Morris, Richard Orban, Susan Petito, Colby Nelson Phillips, Sandy Phillips, Gregory Pittman, Ben Proctor, John Przylepa, Kevin Reed, Diane and Rick Savage, Laura Scharle (Indian River Life-Saving Museum), Allen Sklar, Vic Sprecher, Mike Stone, Debi Tyler, Bobby Wagner, Sean Williams, and Bill Wise.

INTRODUCTION

The summer of 2019 marks the 90th year of organized lifeguard protection along Maryland's Atlantic coast. When the town of Ocean City, barely a village in 1930, hired the first members of the Ocean City Beach Patrol, no one could have envisioned that nine decades later the patrol would be comprised of over 200 highly trained "surf rescue technicians" (SRTs), men and women guarding over nine miles of beach and surf. It is remarkable that only three captains have led this effort for 80 percent of the organization's history, and it was during only the first five years that neither one of these future captains was an Ocean City lifeguard. The story is primarily a narrative of young men and women serving under three captains: Robert S. Craig, George Schoepf, and Butch Arbin.

Lifesaving along the ocean shore, of course, has a history reaching into the 19th century, but it is a story of shipwrecks and rescues of sailors seeking the safety of the barrier islands after their ships ran aground. US Life-Saving Service life-saving stations are notable precursors of the United States Coast Guard in 1915; indeed, the local Ocean City "old Coast Guard station" was built in the 19th century for the Life-Saving Service; after 1930, it had a long association with the OCBP. In the 1960s, the station on Caroline Street was adapted for use as the headquarters office, equipment storage facility, and barracks for the lifeguards. Thirty-plus years earlier, it was on the beach in front of this building, with its lookout tower and rescue boat at the ready, that the town's earliest "fanny dippers," bathers, and swimmers of varied abilities, first made a practice of entering the ocean "in front of the lifeguard"—or more accurately, the lifeguard followed the crowds as they moved away from the Coast Guard station whenever the ocean eroded the beach at Caroline Street. Robert S. Craig has confessed about the credentials he brought to the job in 1935, the beach patrol's sixth summer: "Can you swim?" a city councilman inquired, and when Craig admitted that he could, the councilman said, "then go speak to the captain and tell him I said to hire you."

Today, Ocean City's lifeguards endure a more rigorous rite of passage into the ranks of the Ocean City Beach Patrol. Today's SRTs comprise a highly professional, well-trained, and responsible organization of "athletes with a buoy" into whose ranks many aspire to enter. They have recorded over 4,750 rescues in a single summer (2005); three years later, 2,070 distressed swimmers were pulled out of rip currents and rescued from storm-induced high surf over a memorable nine-day period in mid-July. The intention is always the same, in calm weather or stormy seas: no one is allowed to drown in Ocean City waters, and as Captain Craig always reminded his team, "No excuse is ever good enough." In recent years, leaders of beach patrols from across the United States and as far away as Rio de Janeiro have come to Ocean City to consult and learn how this remarkable organization has maintained such an enviable record of safety. There is a double meaning to the slogan "Lifeguards for life."

The procedures and innovations instituted by Captain Craig (now well-established practices) were supplemented by the more extensive organized training, competitive spirit, and focus on

physical fitness under George Schoepf. The advances in technology, the more sophisticated equipment, and the administrative skills with which Captain Arbin has stewarded the patrol into the 21st century have contributed to the creation of a modern, efficient organization, operating with the precision of a fine-tuned machine. Just as important is the preservation of long-standing attitudes about the true nature of the job: not least among the firmly established beach patrol traditions is the emphasis patrol leaders place on the role of character building. Senior lifeguards mentor rookies and continue to train and fine-tune the skills of less-experienced guards while maintaining an esprit de corps that patrol alumni testify lasts a lifetime. Captain Arbin counsels his lifeguards, "Yours is not just a job, it is a job of significance." Arbin reminds his lifeguards that town citizens and beach patrons continually observe the demeanor and attitude of members of the beach patrol, and many praise the skills of these athletes, some testifying "you saved my life, and words cannot express my thanks." "For the rest of their lives and for the rest of your life," Arbin counsels his guards, "your actions take on real significance." Throughout the history of the Ocean City Beach Patrol, from Captain Craig to Captain Arbin, the cultivation of individual responsibility and personal accountability has remained the central job benefit and job requirement of these young men and women.

Other observers of the beach patrol in action find remarkable the codified (but to them undecipherable) communications by red semaphore flags between lifeguards who pass messages along the beach, most of which pertain to lost children. The lifeguard's first message to parents is that when a child wanders off, he or she almost never goes into the water, but rather keeps walking, expecting to find a parent or guardian under the next umbrella. Because they walk along the umbrella line, a lifeguard farther up the beach will find the child; hence the semaphore messages. To the author's best knowledge, the all-time record for such treks in search of a "lost parent" is the case of a young child who got lost on Fifth Street, never asked for help, and apparently never cried, until found at a bonfire beach party at 8:00 p.m. that evening in the sand dunes around Eighty-Seventh Street, over five miles north. The most outrageous case was recalled by Captain Craig. By the end of one work day, a lost child had not yet been found, so the father dropped by the captain's house on St. Louis Avenue to inform him of the situation. He then asked the captain (in a tone that was more like informing him), that since he was already late returning to Baltimore, could he phone Captain Craig on Monday to see if the child had turned up? Somewhat taken aback, the patriarch of the beach patrol then gave the man some fatherly advice, inviting him, in no uncertain terms, to wait on the captain's porch. A well-directed phone call resulted in the information that the man could retrieve his child at the police station on his way out of town.

If a picture is worth a thousand words, then each of the illustrations that follows conveys its own story, a narrative linked to an individual lifeguard or to a larger group of SRTs who train together and who have each other's back whenever rescues involve multiple swimmers in trouble. "I still marvel at the skill that your father demonstrated in choosing his guards," a member of the lifeguard organization from the 1950s recently wrote to me. "There were few, if any, conflicts among the guys, and most moved on in life to become successful at their chosen careers." Those careers included college professors as well as the chancellor of a state university; politicians, including a US congressman; and businessmen, engineers, lawyers, and doctors. Each is part of the history of an institution that over the years has saved countless lives.

Group pictures on the pages that follow record the entire patrol as it existed during selected years and give evidence of the extraordinary growth in numbers over time. Photographs of competitions and OCBP champions document how the Ocean City Beach Patrol has fared against other lifeguard organizations in regional and national lifeguard contests. Capt. Robert S. Craig's lifelong hobby as a photographer is evidenced in the many individual and group photographs he took of the beach patrol, as well as in scenes of Ocean City printed as postcards, images composed for public relations purposes, and snapshots kept as personal mementos including news clippings he preserved in a scrapbook documenting his career.

Ocean City has kept pace with, and often led, national developments in lifesaving. In the late 1980s, Capt. George Schoepf established a Surf Rescue Academy for rookies to formalize more

effectively the training of newly hired lifeguards. Butch Arbin's interest in education reached farther back when he organized beach-day activities coordinated with local summer camps, instituted public information sessions on the beach, and in 2000 established a Junior Beach Patrol program to provide kids aged 10–17 experiences in water safety and rescue. The Junior Beach Patrol experience led many (once they were old enough) to try out and be hired as beach patrol members; but in the meantime, such programs contributed immeasurably to the knowledge and safe practices of young swimmers at the ocean.

In all these activities, the Ocean City Beach Patrol fulfills its three-part mission to educate, to prevent, and to intervene.

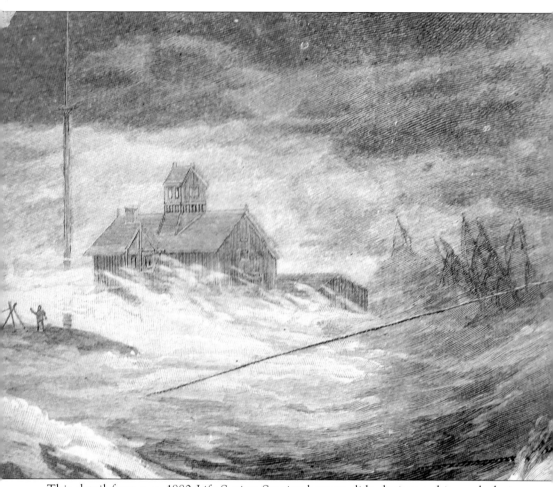

This detail from a c. 1880 Life-Saving Service lantern slide depicts a shipwreck during a storm with a life-saving station in the background. (Courtesy the Indian River Life-Saving Station Museum.)

One

THE FOUNDING YEARS

Ocean City dates its foundation to July 4, 1875, the day of the opening of the Atlantic Hotel. Three years later, a federal agency that had begun as a volunteer service of the Treasury Department's Revenue Marine Bureau was formally established as the US Life-Saving Service. Life-saving stations were projected to be built every six to eight miles along the Atlantic coast, and one of the first was erected in 1878 on the beach at Caroline Street in Ocean City.

The period between the establishment of the Ocean City Beach Patrol in 1930 and the captaincy of Robert S. Craig in 1946 were the years of the Great Depression and World War II, during which the patrol was headed by no fewer than seven captains. Edward Lee Carey served for seven summers (1930–1933 and 1939–1941), with others heading the patrol for only one or two seasons: John Laws (1934), Barney McCabe (1935), Harry Kelley (1936–1937), Collins Elliott (1938), Tom Price (1942 and 1945), Jim Parker (1943–1944), and Bill Pacey (briefly in 1945). Begun with only two lifeguards "following the crowds," the beach patrol maintained a complement of about seven regular lifeguards through 1936, edging up to 18 in 1946, when Robert S. Craig began his tenure.

The patrol's equipment began with the issuance to each man of a bottle of smelling salts, a bottle of iodine, and a 30-inch ring buoy. With the lifeguards' pay at $10 per week in 1931, a lifeguard benefit dance was initiated, and although not held in 1932, it continued annually in 1933 for another 32 years through 1965. The dance raised end-of-summer bonus money for the lifeguards, and in its early years paid for needed equipment, including the patrol's first rescue boats. Another notable activity during the founding years of the beach patrol was the initiation in 1939 of a formal course in lifesaving and water safety taught by Robert Craig, who had become a qualified Red Cross instructor that year. It was an early step in the professionalization of the beach patrol.

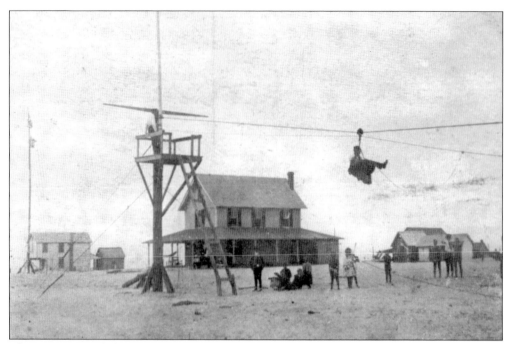

The 1903 postcard above by George W. Rafferty illustrates the operation of a beach pole, shore rescue line, and pulleys employed by life-saving station surfmen in ocean rescues. It is preserved at the Indian River Life-Saving Station Museum in lower Delaware (below). From the shore, a Lyle gun (a small cannon) would fire a projectile resembling a window sash weight attached to a light line about 600–700 feet out to a ship aground on a sandbar. Then a heavier rescue rope, pulled between the rescue pole and floundering ship, would be raised to the pole to provide a rescue line with a pulley system to bring victims ashore. (Above, courtesy the Indian River Life-Saving Station Museum; below, author photograph.)

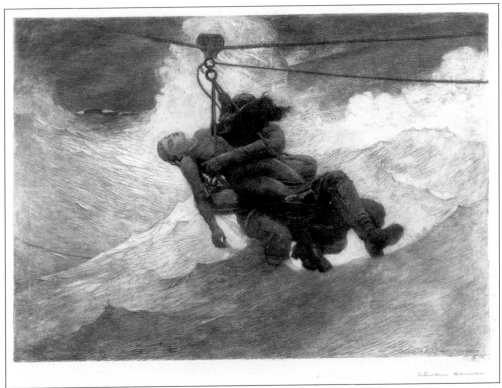

Copies of Winslow Homer's 1884 painting *The Life Line* appeared in the popular press of the day. Depicting a surf rescue, the painting is by the prominent American realist who captured numerous subjects relating to the ocean from Maine to the Caribbean. The original oil is at the Philadelphia Museum of Art; an etching is at the Metropolitan Museum of Art in New York. (Public domain.)

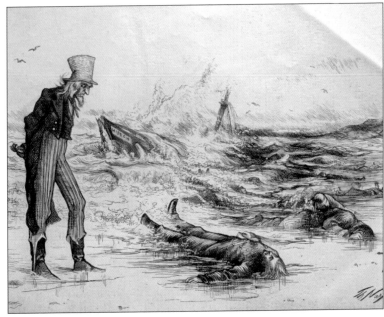

This drawing from *Harpers's Weekly* of December 29, 1877, depicts drowned victims from the shipwrecked *Huron*; six months after its publication, Pres. Rutherford B. Hayes signed into law a bill establishing the US Life-Saving Service. (Courtesy the Indian River Life-Saving Station Museum.)

13

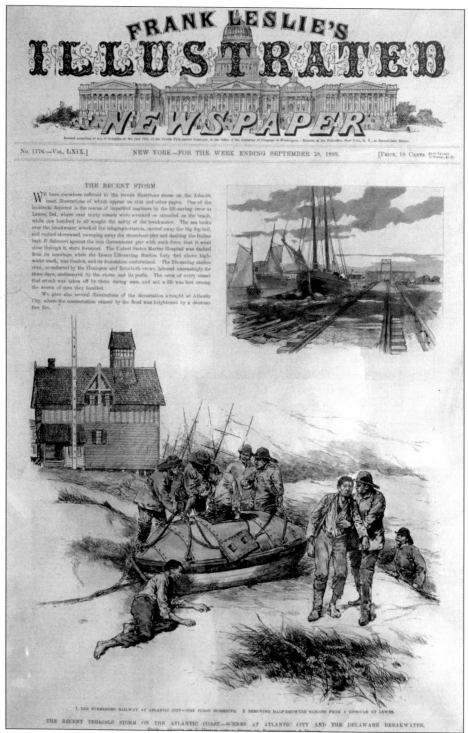

The September 28, 1889, issue of *Frank Leslie's Illustrated Newspaper* shows the life-saving station at Lewes, Delaware, and the rescue of a "half drowned sailor" with the aid of a life cab pulled ashore by rescue ropes. (Courtesy the Indian River Life-Saving Station Museum.)

The barrier island during the late 19th and early 20th centuries was virtually uninhabited north of the small fishing village of Ocean City, other than the patrolling surfmen of the life-saving stations at Ocean City and Indian River, and later the Isle of Wight. (Author photograph.)

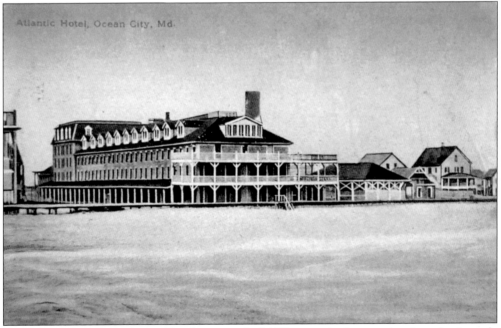

Atlantic Hotel, Ocean City, Md.

This postcard of the Atlantic Hotel, postmarked 1910, records the grandest hostelry in early Ocean City, originally opened in 1875 and enlarged after a fire in 1925. The Windsor Resort and fishing shanties were south of the hotel, and for many years only cottages were located to the north, extending only a dozen or so blocks and sparsely spaced before the 1920s. (Courtesy the Fisher collection.)

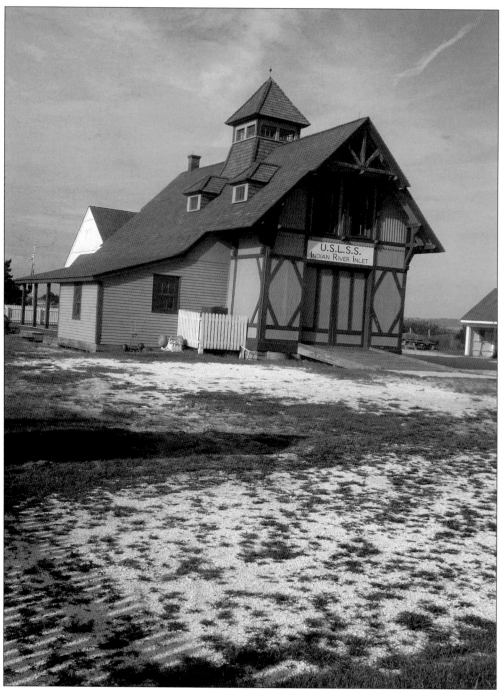

The Indian River Life-Saving Station was built in 1876, and in 1877 moved 400 feet farther back from the shoreline. It was used briefly by the Coast Guard and damaged in the 1962 Ash Wednesday storm, but was subsequently restored to its 1905 appearance and opened as a Delaware state museum. It is located 13½ miles north of the Maryland-Delaware state line. (Author photograph.)

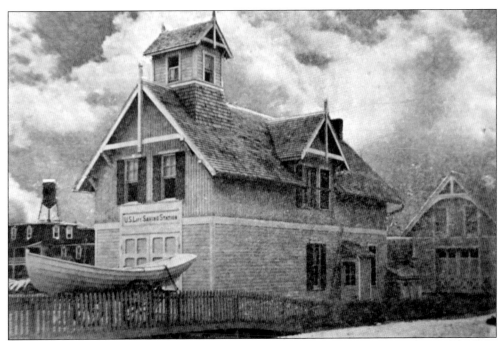

Twenty-one and a half miles south of the Indian River Life-Saving Station, the Ocean City Life-Saving Station (above) was erected on the beach at Caroline Street in 1878. In between, five and a half miles north of the Ocean City station, the service erected the Isle of Wight Life-Saving Station in 1897, sited at the present-day location of the Antigua Condominium tower between Eighty-Fifth and Eighty-Sixth Streets. The building was later used as a social dance hall known as the Dunes Club, frequented by beach boys and lifeguards in the late 1950s, but it was damaged by the March 1962 storm and subsequently razed. (Above, courtesy the Fisher collection; below, photograph by Floyd "Doc" Turner, courtesy Bunk Mann.)

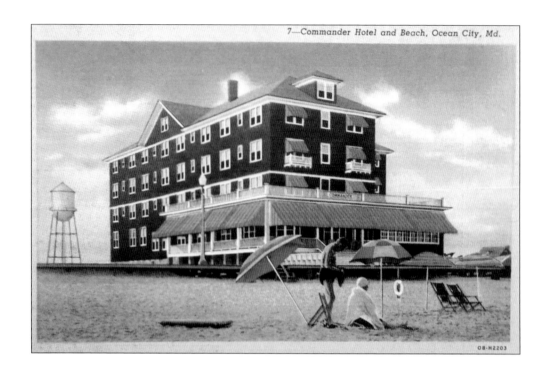

When the Commander Hotel was built on the beach at Fourteenth Street in 1928–1930, its site was considered remote, so far out in the north dunes that many thought that no one would stay there. The only nearby structure was the Dominican fathers' retreat, and only a few cottages had been erected by 1940 when the postcard above was made. The Dominican college, shown below with its tower in a postcard view by George Connor, was sited near today's Thirteenth Street beach and once served as the St. Rose Industrial Home. (Both, courtesy the Fisher collection.)

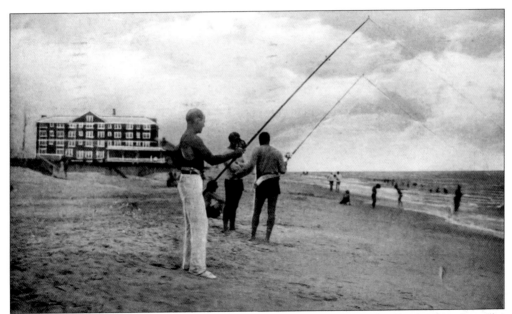

The beachfront from Ninth to Fourteenth Streets was only sporadically developed in the 1920s–1930s, so at the time of the establishment of the beach patrol, the beach was used more for surf fishing than swimming; in the distance is the 1930 Commander Hotel. The card is postmarked 1937. (Courtesy the Fisher collection.)

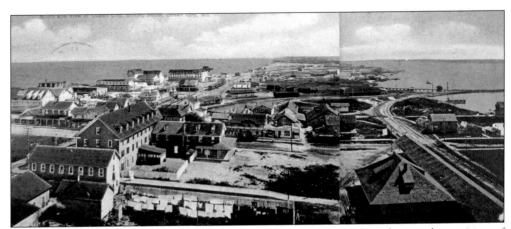

This c. 1910 photograph looking south toward downtown Ocean City shows a distant view of the fishing shanty end of town and the undeveloped barrier island beyond, much as the town existed when the beach patrol was formed in 1930—that is, prior to the 1933 storm that cut the inlet to separate Ocean City from Assateague Island. (Courtesy the Fisher collection.)

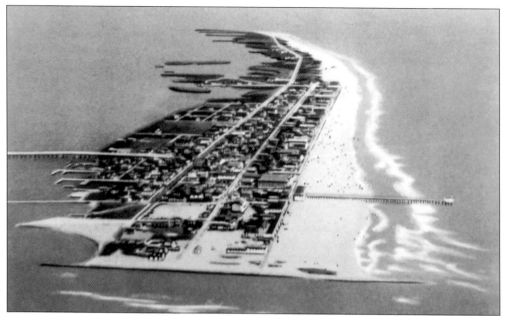

This aerial view shows the extent of Ocean City's development soon after the establishment of the OCBP: the inlet was formed, although the impression that the island ends at the top of the view is misleading. North of Fourteenth Street (site of the 1930 Commander Hotel) was where the street grid development ended, with only barren sand, marsh, and coastal highway beyond. (Courtesy the Fisher collection.)

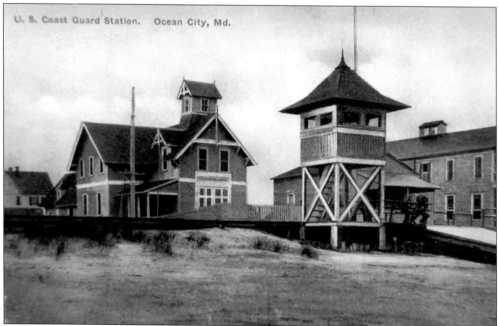

The Coast Guard tower at Caroline Street provided a watchtower from which surfmen could survey the nearby ocean. Early ocean bathers swam in front of the Coast Guard station, and the earliest lifeguards were concentrated here. In 1938, after the formation of the inlet, a taller tower was built at the south end of town overlooking the inlet. (Courtesy the Fisher collection.)

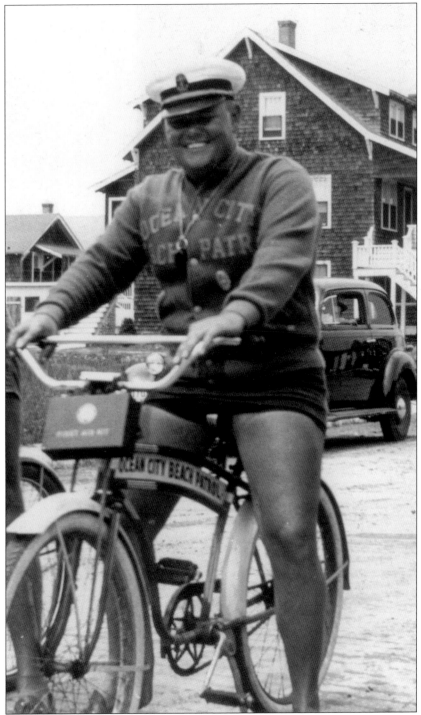

Edward Lee Carey, whom Robert S. Craig said was "built like a fireplug," was the first captain of OCBP, hired in 1930 along with John Laws for the opening weeks of the summer. There were seven on the patrol by the end of that first year, and 14 by the end of the decade. Carey served as captain from 1930 to 1933 and 1939 to 1941. (Courtesy the Robert S. Craig collection.)

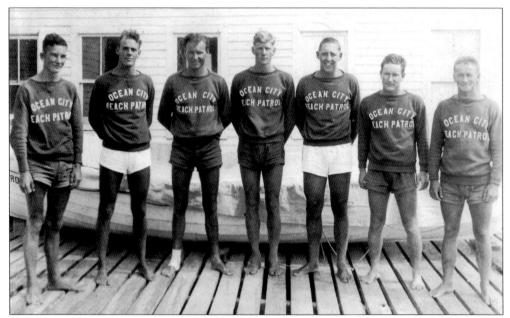

Seven members of the 1936 Ocean City Beach Patrol pose for what would become a tradition, the annual group photograph. Harry Kelley (far right) was captain (1936–1937), Jim Parker (far left and a rookie in 1936) became captain in 1943–1944, and Robert S. Craig (third from right), was promoted to captain in 1946 and served until 1987. Both Kelley and Craig were first hired in 1935. (Courtesy OCBP.)

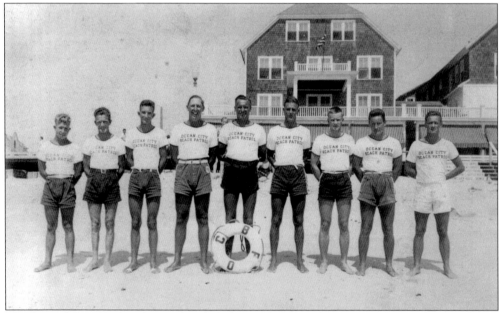

Members of the 1937 beach patrol included, from left to right, Cutie Savage, Bill Purnell, Jim Parker, Robert S. Craig, Collins Elliott, Gary Todd, Sam Moore, Tommy Dukehart, and Harry Kelley (captain). Craig once noted that Kelley was the only guard he worked with in the early years who could beat him swimming. Kelley served as mayor of Ocean City from 1970 to 1985. (Courtesy the Robert S. Craig collection.)

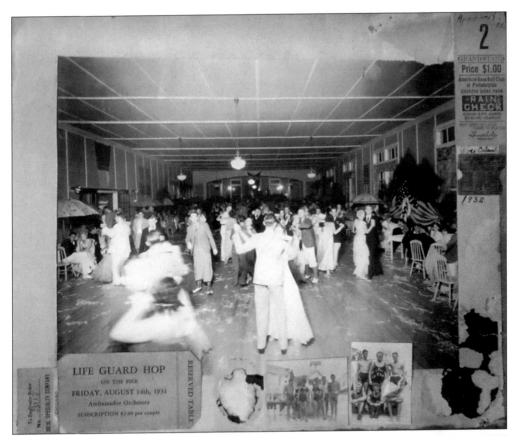

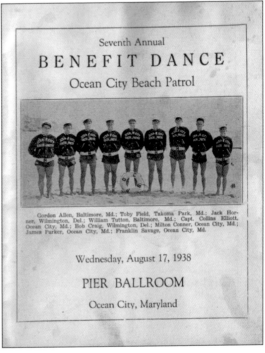

The first annual lifeguard benefit dance was held at the pier ballroom in 1931, but it was not held the following year due to the Depression. From 1933 through 1965, lifeguard dances became an anticipated late-summer social event, attracting top national and regional bands. The cost to dance to the music of the Ambassador Orchestra in 1931 was $2 per couple. The 1938 lifeguard dance booklet included a photograph on its cover of the nine-member beach patrol, dressed in new uniform bathing trunks, jackets, and caps, standing behind the standard ring buoy employed throughout the 1930s and 1940s. One 1938 advertisement promoted an act scheduled to appear five days after the lifeguard dance: "Chick Webb (in person) and His Orchestra with Ella Fitzgerald." (Above, courtesy OCBP; right, author's collection.)

Seventh Annual

BENEFIT DANCE

Ocean City Beach Patrol

Gordon Allen, Baltimore, Md.; Toby Field, Takoma Park, Md.; Jack Horner, Wilmington, Del.; William Tutton, Baltimore, Md.; Capt. Collins Elliott, Ocean City, Md.; Bob Craig, Wilmington, Del.; Milton Conner, Ocean City, Md.; James Parker, Ocean City, Md.; Franklin Savage, Ocean City, Md.

Wednesday, August 17, 1938

PIER BALLROOM

Ocean City, Maryland

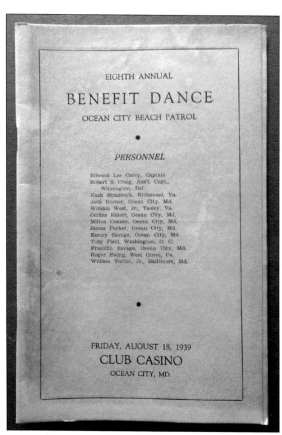

Although several early booklet covers did not have photographs (the 1939 booklet shown at left is an example), they typically included a two-page history of the beach patrol. Annual photographs had become the norm, with the captain often centered in the group behind the ring buoy, as Capt. Edward Lee Carey is below. In 1939, Robert Craig offered Red Cross instruction in water safety and lifesaving, based on coursework he had undertaken while a graduate student at the University of Pennsylvania. In this 1939 photograph of the OCBP, Red Cross badges are visible on Craig's and Collins Elliott's bathing trunks (third and fourth from right, standing). (Left, author's collection; below, courtesy the Robert S. Craig collection.)

31st ANNUAL BENEFIT

DANCE...

OCEAN CITY BEACH PATROL

Pier Ballroom

Tues. Aug. 27, 1963 **Ocean City, Md.**

Distinguished by its red typography and standardized format, the 1963 lifeguard dance booklet cover is typical of the 1950s and 1960s; its cover photograph now includes 46 lifeguards. Within, a half-page advertisement reads, "Thanks Robert, 8th Street, To the best looking guard on the beach from the best looking gals on the beach," signed by 16 females. The author (back row, sixth from left) guarded Eighth Street. (Author's collection.)

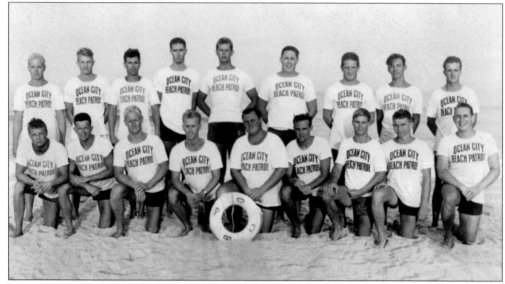

The 1941 OCBP photograph (above) shows a heftier Robert S. Craig (back row, fourth from right) who had married the previous August. Bill West (first row, far right) was in his wedding. John Dale Showell (back row, center), whose family operated the bath house, saltwater swimming pool, bowling alley, and Showell's Theatre at Division Street, would later build the Castle in the Sand Hotel at Thirty-Seventh Street. The year 1942 brought new guards to the patrol, and a new young captain, Tommy Price. The 14 members (below) included, from left to right, (first row) John Neunnan and Tom Price; (second row) George Lynch, Hamilton Boblitz, Frank Page, and John Page; (third row) Ernest Travis, Ed Robertson, Robert S. Craig, Gordon Shipley, and Earl Simpson; (fourth row) James Parker (assistant captain), Toby Field, and John Dale Showell. (Both, courtesy the Robert S. Craig collection.)

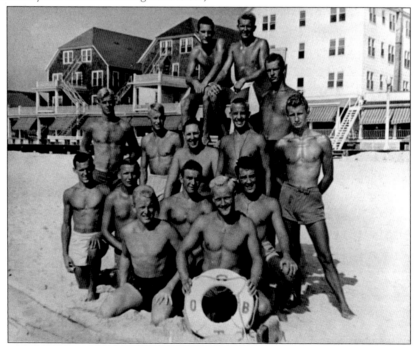

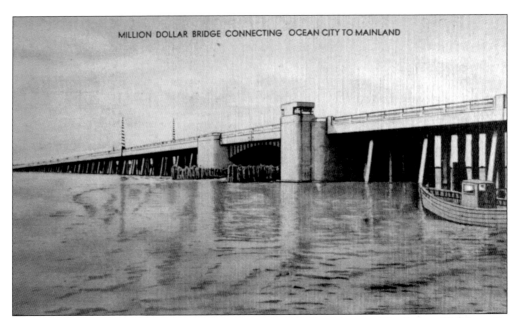

The opening of the "million dollar bridge" (now Harry Kelley Memorial Bridge) in 1942 brought greater accessibility by car to the town; although growth was slow during the war, a postwar boom expanded the town north of Fifteenth Street, creating "motel row" along the beach from Fifteenth to Thirty-Third Streets. (Courtesy the Fisher collection.)

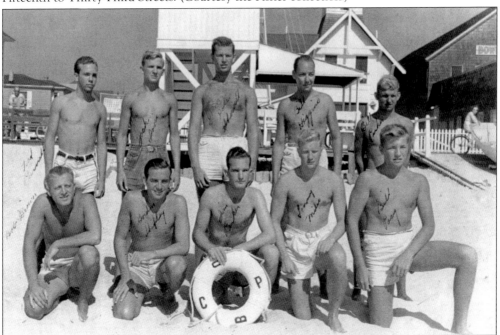

Jim Parker, who joined the patrol in 1936, served as captain in 1943 and 1944, then Bill Pacey served briefly in 1945 until Tom Price returned from the war. Pictured here in June 1943 are, from left to right, (kneeling) Bob Brown, Gordon Shipley, Jim Parker, Sonny Miles, and Bill Pacey; (standing) Ted Purnell, Jack Davis, John Dale Showell, Bill Higgins, and Bill Parker. (Courtesy the Robert S. Craig collection.)

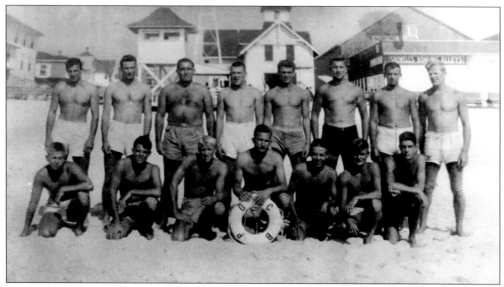

Robert S. Craig is conspicuously absent from group photographs of 1943 to 1945. In 1943, he worked weekends while completing his master's degree. In 1944, his draft board required him to stay in St. Louis until further notice; his second son (the author) had been born in May 1944, and the elder Craig was working in an ordnance factory while expecting to be drafted. He never was, and returned to OCBP for the summer of 1945. The late 1944 photograph above, taken on the beach, shows Jim Parker in his second year as captain. The July 1945 photograph below, with Sam Hill holding a dog, documents Bill Pacey as captain (in T-shirt), and, in front of him, rookie Lucky Jordan. At summer's end, Jordan joined the Navy and returned to OCBP in 1951. (Both, courtesy the Robert S. Craig collection.)

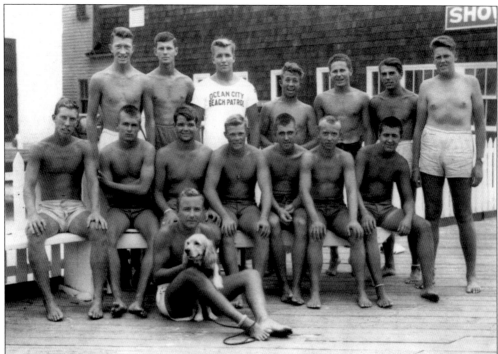

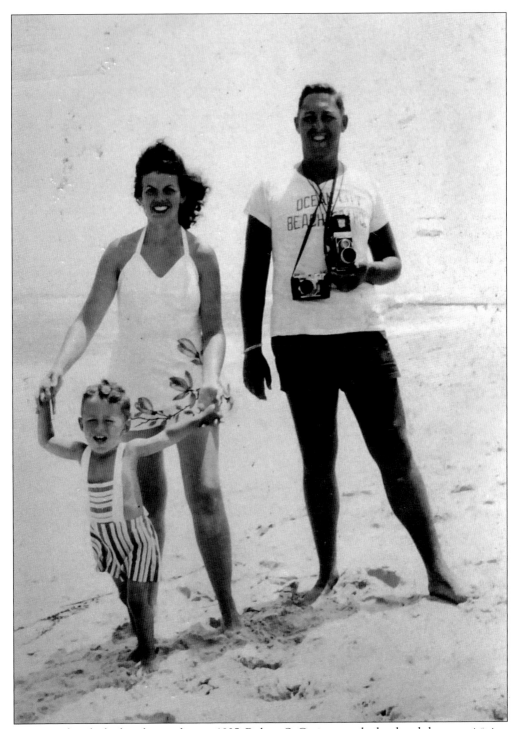

Associated with the beach patrol since 1935, Robert S. Craig was asked to head the organization in 1946; he remained captain until his retirement in 1987. Shown here around 1946 is Captain Craig, his wife Virginia, and the author. With two cameras around his neck, the snapshot records Craig's emerging hobby, photography. (Courtesy the Robert S. Craig collection.)

Capt. Robert S. Craig (1918–2009; OCBP 1935–1987) became the iconic personification of lifeguarding on the Maryland coast, well known to state governors, city mayors, hundreds of his beach patrol members past and active, and countless vacationers; Craig was dubbed a legend of lifesaving even before he retired from what John Sherwood of the *Washington Post*, in a July 3, 1981 article, called his endless summer. (Courtesy the Robert S. Craig collection.)

Two

THE ROBERT S. CRAIG ERA

When OCBP lifeguards from the 1940s, 1950s, and 1960s returned to Ocean City in 2000 for the first of what continue today as triennial lifeguard reunions, the reunion organizer looked around the crowded hotel reception room and remarked, "Captain Craig hired everyone here." He was acknowledging the remarkable 52-year legacy of Capt. Robert S. Craig, who mentored boys in a rite of passage to manhood and, in 1978, hired the first female on the patrol. The junior officers of his late career became the senior officers of subsequent years, including both successor captains under whose leadership OCBP has continued to thrive.

Robert S. Craig introduced torpedo buoys as the lifeguard's singular piece of critical rescue equipment, and initiated semaphore as the primary communication among lifeguards. Craig's standards of discipline, his advocacy of personal responsibility and accountability, and his promotion of good character, of which he was an unfailing embodiment, remain hallmarks of the patrol's reputation as the town's most visible ambassadors. Above all, Craig's lifeguards were Ocean City's guardians of water safety and first response for any swimmer in distress in high surf or rip current or any vacationer experiencing an emergency on the beach or in the ocean.

Considered by many to be the patriarch of the beach patrol, Captain Craig was a model administrator whose responsibilities grew exponentially during his tenure when the coastline he was asked to protect expanded threefold and the size of the patrol grew from 18 men when he was named captain in 1946 to approximately 140 men and women when he retired in 1987. With respect to his personal outlook on life and "expectation for good" in people, the high standards for personal conduct and job performance that he demanded reflected the seriousness of the job. He is remembered for the advice given to his lifeguards—if a swimmer is lost in the surf or a child drowns on their watch, "how would you feel? Stay vigilant!" Those who worked for him simply did not want to disappoint him, to which he would retort, "You must never disappoint yourself."

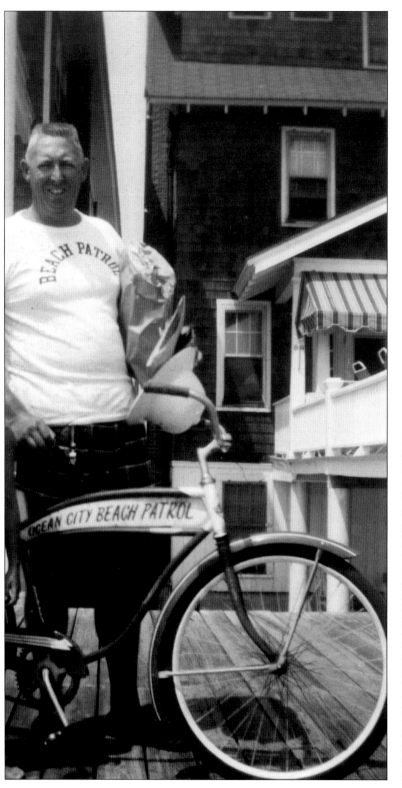

Perhaps the earliest recollections of Captain Craig are of him patrolling by bicycle along the boardwalk, supervising his lifeguards. Craig was the only person authorized to ride a bicycle on the boardwalk after 10:00 a.m. While he continued to wear his classic moccasins, whistle, and beach patrol T-shirt, the pith helmet and plaid bathing suit were not permanent features. (Courtesy the Robert S. Craig collection.)

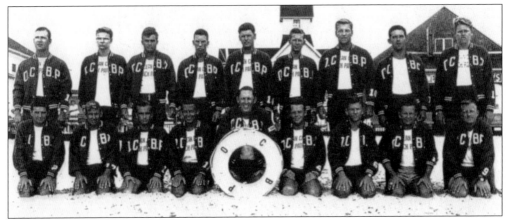

When Robert S. Craig was named captain in 1946, there were 18 members of the beach patrol. The patrol still used a ring buoy; Craig is centered behind it. Behind him is George Feehley, who would later gain much success as a senior competitor in lifeguard contests. And at Feehley's left elbow stands Frank S. Craig, the captain's younger brother and a 1946 rookie. (Courtesy the Robert S. Craig collection.)

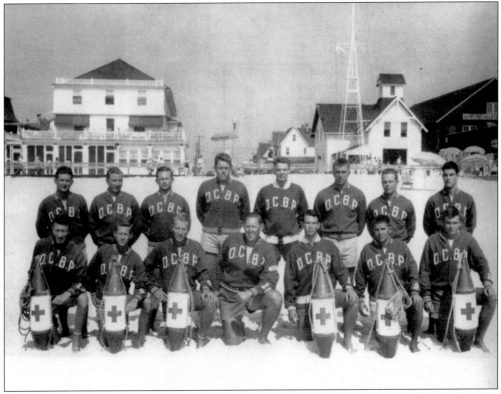

The annual photograph in 1947 shows off Craig's first innovation in surf rescue, the introduction to OCBP of torpedo buoys. They were fabricated to Craig's design at a local sheet metal shop and have been used in Ocean City ever since, although in 1982 the patrol began experimenting with, and eventually adopted, a plastic model torpedo "can buoy." (Courtesy the Robert S. Craig collection.)

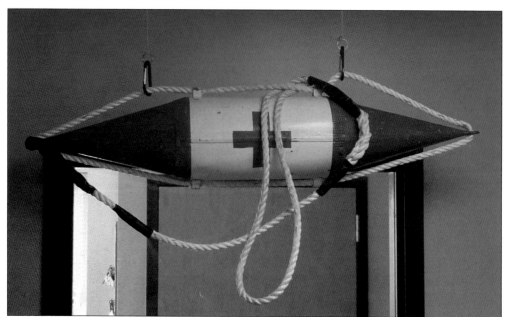

Craig's original design of the torpedo buoy had red pointed ends and a white midsection with a red cross. Rope was strung through metal eyes at the ends and was loose enough against the sides of the buoy to serve as a handle. A spliced end loop served as a shoulder halter with the rope extended to a length adequately long to float semi-independently behind the swimmer without his feet kicking it. Seen below in the 1950s, Craig poses with a buoy, a prototype of which he had seen on a beach in Florida. Introduced to OCBP in 1947, it became standard equipment for the town's lifeguards until supplanted in the early 1980s by plastic buoys based on California designs. (Above, photograph by Robert M. Craig; below, courtesy the Robert S. Craig collection.)

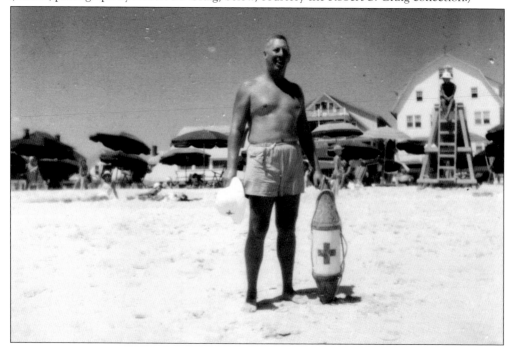

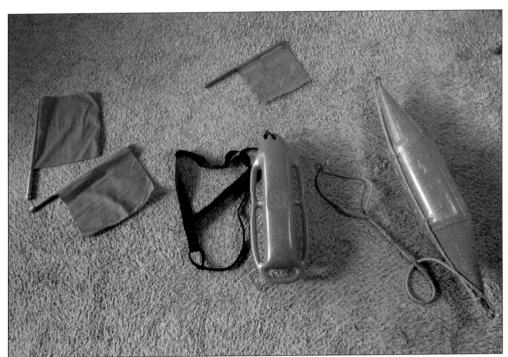

Early OCBP equipment in the Robert Wagner collection includes an early torpedo buoy (painted with remaindered orange school bus paint), a later orange "can buoy," an original cloth flag frayed from use, and a pair of red semaphore flags made from hemmed dinner napkins to solve the frayed-edge problem. The napkins were secured to half dowels (cut lengthways, then reaffixed). (Author photograph.)

The semaphore alphabet allowed lifeguards to spell out any message in any language. The flag system was used primarily to send messages about lost and found children. A guard sending a message could continue to watch the water; the receiving guard was more focused on reading the message for which arm positions were reversed, and the reader could not control the speed (or sloppiness) of the sender's communication. (Courtesy OCBP.)

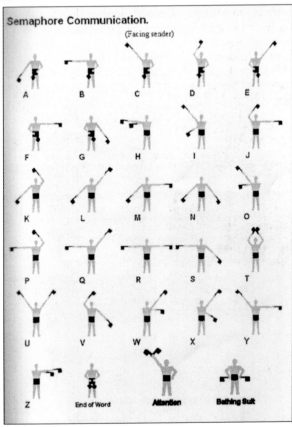

Semaphore Communication.

(Facing sender)

A B C D E
F G H I J
K L M N O
P Q R S T
U V W X Y
Z End of Word Attention Bathing Suit

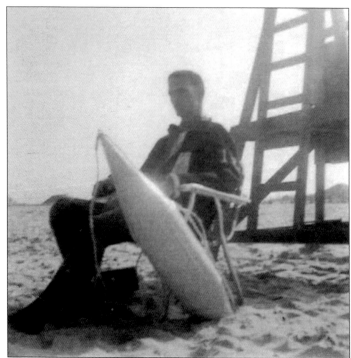

This 1960 photograph of lifeguard George Thompson shows the classic beach pose of the era: the torpedo buoy angled in the sand and rope loop set up in proper position for the guard to grab, pull over his shoulder, and race to the rescue. The buoy was designed to cut through breaking surf with as little drag as possible. (Courtesy the Robert S. Craig collection.)

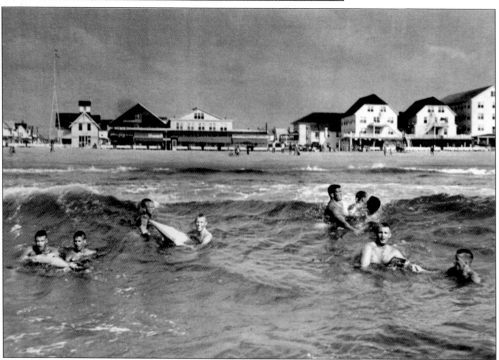

Photographer A. Aubrey Bodine recorded a torpedo buoy rescue practice drill from the vantage point of a distressed swimmer carried far from shore by a rip current. The guards were training in front of the Coast Guard station on Carolina Street. (Photograph by A. Aubrey Bodine, courtesy Jennifer Bodine.)

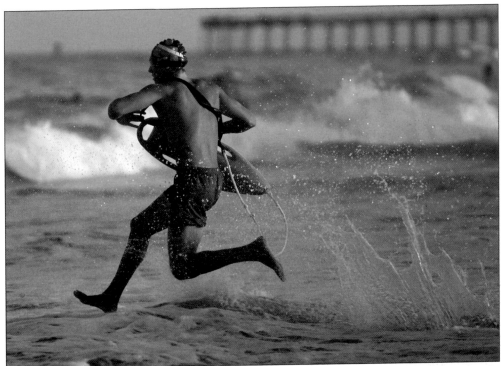

Lifeguards grab their can buoys and race to make a rescue, diving over and under waves. As Capt. Butch Arbin has noted, the job has not changed since the days of Captain Craig: it is still essentially the work of "an athlete with a buoy." (Both photographs by John Dunnigan.)

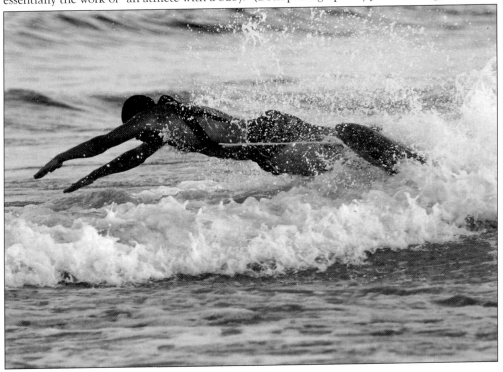

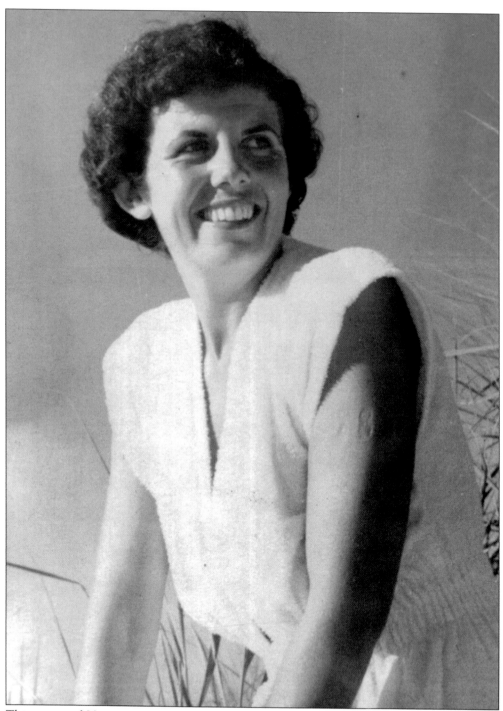

This image of Virginia Lee Mason Craig, taken by Captain Craig, is an early example of Craig's hobby as a photographer. Throughout the years, he posed family and friends, individual lifeguards, and groups including sports teams for yearbook pictures, graduation ceremonies, lifeguards gathered for the annual group photograph, and wedding parties. (Photograph by Robert S. Craig.)

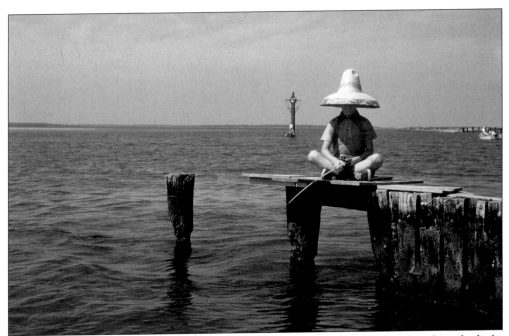

Just Fishin', an early Craig image, captures a bygone era to the extent that most bayside docks are now lost to development; today, the small boy with a fishing pole would need a license to fish in most locales. Some of Craig's early work was published in *Popular Photography* and *U.S. Camera*, the two photography magazines with the widest circulations of their day. (Photograph by Robert S. Craig.)

This beach scene with lifeguard stand photographed by Captain Craig in the 1950s became a popular postcard, one of several Craig produced for the Tingle Printing Company, owned by his brother-in-law's brother, Fred Breuckmann. (Photograph by Robert S. Craig.)

Two postcards, each with a beach scene photographed by Captain Craig, were published as a scenic view or with a stencil message overlay reading "A Great Big HELLO from Ocean City Maryland." The family referred to this as the card with the dropped comma. (Both photographs by Robert S. Craig.)

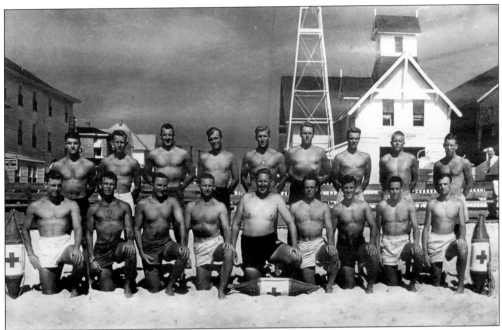

Three versions of the annual OCBP picture survive from 1948—one with jackets, one with T-shirts, and one shirtless. OCBP photographs included bare-chested lifeguards as early as 1942, despite the town's prudish ordinance that shirts were required on men west of the beach. As recently as 1945, a member of the Ocean City (New Jersey) Beach Patrol had been arrested there for not wearing a top on his bathing suit. Above, Craig's brother Frank (second row, second from left) and brother-in-law Joe Chatham (second row, fourth from left) were lifeguards in 1948. Still displaying the new torpedo buoys in 1948, the patrol had another piece of equipment to show off by 1951 (below): a rescue boat paid for with proceeds from the benefit dance. (Both, courtesy the Robert S. Craig collection.)

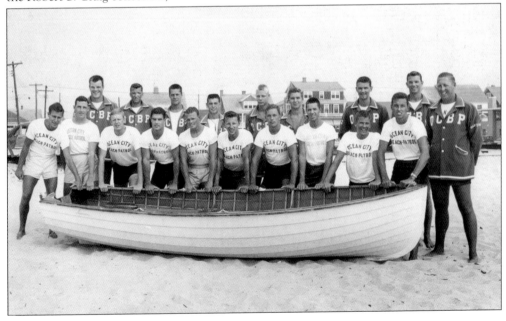

In 1950, George Schoepf joined the Ocean City Beach Patrol. He was named assistant to the captain in 1966, and when Captain Craig retired in 1987, Schoepf was named captain, serving in that capacity until his death in 1997. As the beach patrol expanded and administrative and training demands evolved, the different personalities of Craig and Schoepf complemented each other, as they remained mutually loyal. (Photograph by Robert S. Craig.)

A rookie in 1950, George Schoepf is shown here in a 1951 publicity photograph with, from left to right, (bottom), Asst. Capt. Wilson Fewster and rookie Ben Swan; (top) Art Miksinski and Wade McClusky. McClusky was the son of the World War II pilot by the same name who found the Japanese fleet in the Pacific, leading to the American naval victory at Midway. (Photograph likely by Robert S. Craig, courtesy the Robert S. Craig collection.)

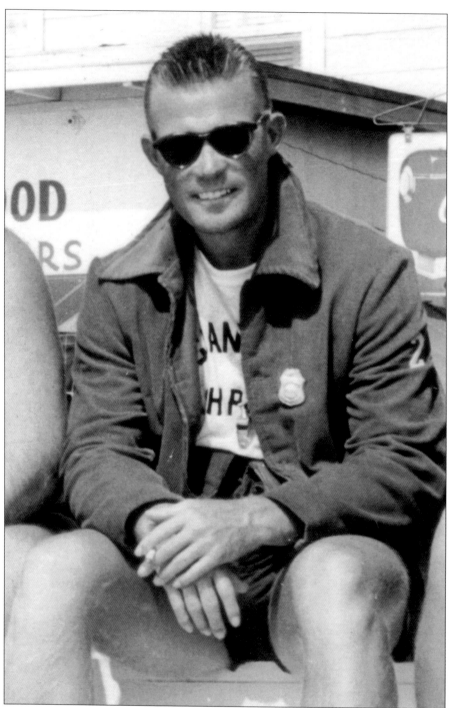

Jarrett Timberlake "Lucky" Jordan (January 5, 1929–June 13, 2015) joined OCBP in 1945, returned in 1951–1955, and was a lifelong colleague of Robert S. Craig and friend to the Craig family. He referred to Craig's eldest son, James, as his best buddy when Jimmy was a kid, and once said of Captain Craig that the beach patrol without Bob Craig would be like Sesame Street without Big Bird. (Photograph by Robert S. Craig.)

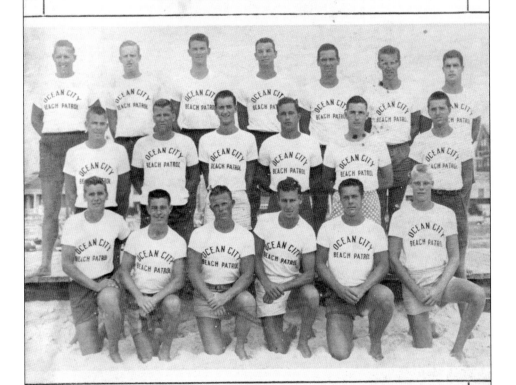

20th ANNUAL BENEFIT
DANCE...

OCEAN CITY BEACH PATROL
Pier Ballroom
Tuesday, Aug. 28, 1951 Ocean City, Md.

Lucky Jordan is pictured in the first row, third from left, on the 1951 dance booklet cover. Jordan is also pictured on page 41 (bottom), standing at center behind the boat next to George Schoepf in the same year. (Courtesy the Robert S. Craig collection.)

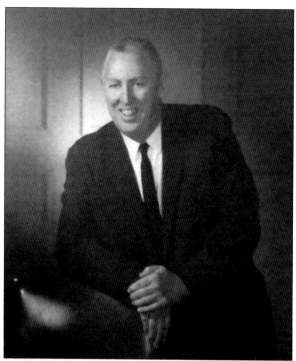

In 1940, Robert S. Craig accepted a teaching job at Principia, a private high school for Christian Scientists in St. Louis, Missouri, where he taught Latin and mathematics, coached various sports teams, sponsored the camera club, and occasionally taught water safety and rescue techniques in the school's swimming pool. Each June, he returned to his summer job in Ocean City, moving there permanently in 1981. (Author's collection.)

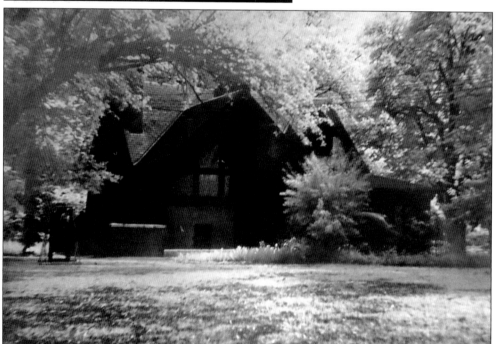

Captain Craig's Missouri address was well known: a converted carriage house and barn remodeled and rented from the school; from here, Craig corresponded yearly with scores of active and hopeful lifeguards, each anticipating receipt of the famous "postcard from 1130 Belt Avenue, St. Louis," indicating he would be tested, hired, or reappointed to the prestigious beach job, administered during winter months from a thousand miles away. (Author's collection.)

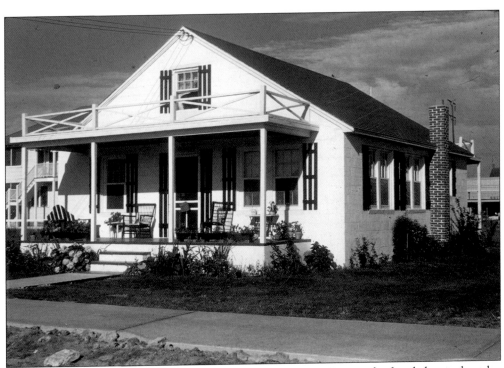

Around 1950, Craig designed and built a summer cottage, Bay Breeze, the family home that also served for many years as an informal seasonal headquarters of the OCBP. Through the years, many lifeguards also found summer housing here, while the family slept in the attic "dormitory." Robert S. and Ginny Craig, pictured below on the Bay Breeze porch, provided rooms for Ward Kovaks, Chip Dashiell, Dick Stewart, and other lifeguards who later became junior officers of the beach patrol. In the 1990s, two annual swim competitions were initiated to honor the Craigs: the captain's one-mile swim and the Ginny Craig quarter-mile swim, the former still held annually on the weekend of the captain's birthday. He would have been 100 in July 2018, eight months after Bay Breeze was officially listed in the National Register of Historic Places. (Both, author's collection.)

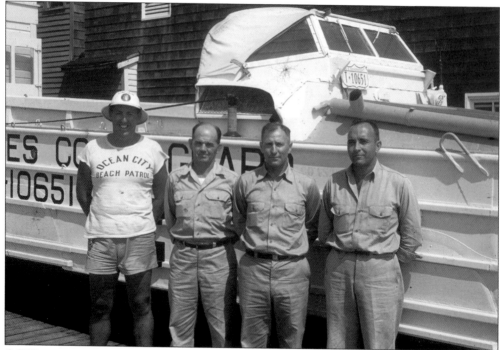

OCBP captain Craig (far left) and Coast Guard chief Edward Lewis (far right) pose with two other Coast Guardsmen in front of a World War II–vintage 2.5-ton amphibious truck known as a DUKW—the manufacturer's code for a type of military, wheeled, amphibious landing craft: D signifies 1942, U means utility (amphibious), K means all-wheel drive, and W indicates two powered rear axles. (Courtesy the Robert S. Craig collection.)

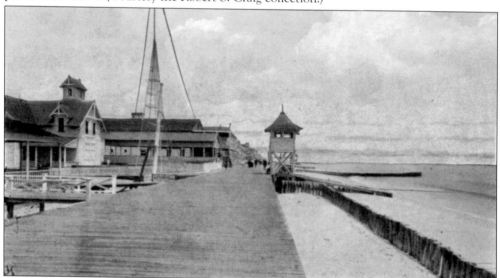

OCBP's lifeguard activities began on the short beach in front of the Caroline Street Coast Guard Station, and the patrol has maintained a close relationship with the Coast Guard ever since. A typical acknowledgement in the 1951 lifeguard dance booklet reads, "Words cannot express the Sincere Appreciation of the BEACH PATROL for the Cooperation of . . . the Ocean City Life Boat Station." (Courtesy the Fisher collection.)

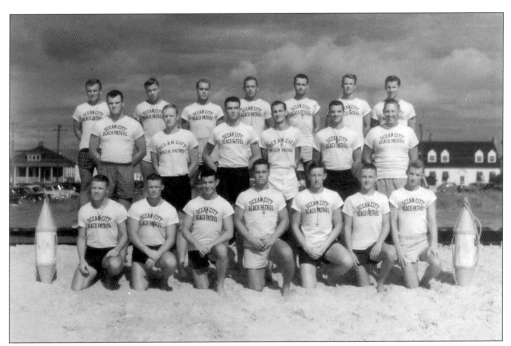

The 1952 patrol witnessed three noteworthy events: the extension of the boardwalk from Fifteenth to Twenty-Second Streets, the opening of the first span of the Chesapeake Bay Bridge, and the introduction of semaphore to the patrol. Pictured above in 1952 are, from left to right, (first row) Frank White, Lucky Jordan, Bebe Smith, Fred Burgee, Ed Burns, Earl Conaway, and Barry Kelly; (second row) Ned Callahan, Pat Lynch, Ben Swan, Ellsworth Boyd, Wade McClusky, and Captain Craig; (third row) Brooks Keller, Clark Moran, unidentified, Art Mikinski, unidentified, Jay Ricks, and George Schoepf. Throughout subsequent years, Ellsworth Boyd published many articles on the beach patrol and its captain. At right, Boyd poses with an original buoy after competing as the most senior athlete in the Lucky Jordan swim at the 2013 reunion. (Above, courtesy the Robert S. Craig collection; right, courtesy Ells Boyd.)

In 1954, one of the youngest lifeguards to join the OCBP, Mitch Maiorana, was hired at the age of 15. He was promoted to lieutenant in 1959, served eight summers through 1961, and was always considered an exemplary lifeguard. In his honor, a run-swim-run competition was held annually between 1999 and 2013, initially sponsored by the local chapter of the United States Lifesaving Association. (Courtesy Jackie DeGroft.)

Capt. Robert S. Craig and Mitch Maiorana pose as proof that lifeguards come in all sizes. (Courtesy Jackie DeGroft.)

Charles "Big Charlie" McCullough guarded Ocean City beaches from 1954 through 1956. At six feet, eight inches and 280 pounds, he even dwarfed the burly Captain Craig, who told *Eastern Shore Times* reporter Julie Summers—for her article "Ocean City Beach Patrol Vet Celebrates 61st Birthday" in the July 11, 1979, paper—that Charlie "had to duck and turn sideways" to enter the captain's office. Promoted to sergeant in his second year and lieutenant in 1956, Big Charlie was remembered by Captain Craig for one of his rescues: "Charlie saw a wave break over a little girl, and Charlie was down there in a second trying to get her to breathe again. He worked . . . for quite a while until she coughed and began to cry. When Charlie looked up, there were tears streaming down his face, too." (Below, photograph by Robert S. Craig; both, courtesy the Robert S. Craig collection.)

A. Aubrey Bodine, a photographer and photojournalist for the *Baltimore Sun's Sunday Sun Magazine*, periodically photographed the Ocean City Beach Patrol. Lifeguard Tom Baker (OCBP 1954–1957) was featured on the magazine section's August 14, 1955, cover as well as in an image in the article "Ocean City Lifeguard: Three Months at the Seashore—With Pay," of the "old" lifeguard barracks (over the city jail), where Baker is pictured sitting on a bunk facing Big Charlie and other guards. Baker was promoted to sergeant in 1956 and lieutenant in 1957; after OCBP, he rose to the rank of general in the Maryland National Guard. (Both photographs by A. Aubrey Bodine, courtesy Jennifer Bodine.)

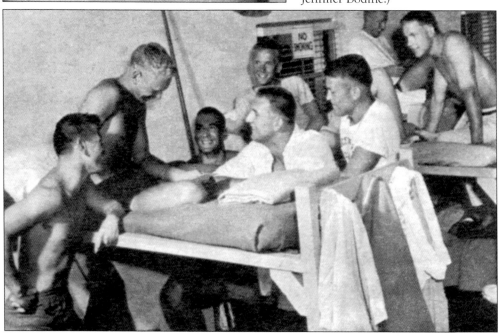

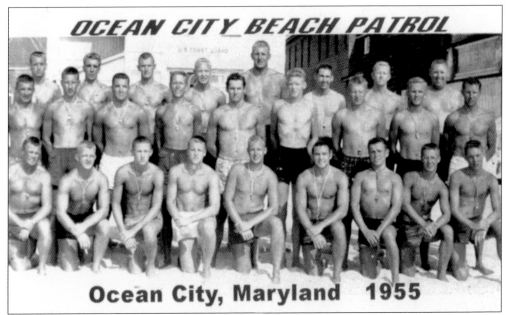

OCEAN CITY BEACH PATROL

Ocean City, Maryland 1955

The 1955 patrol included Sgt. "Big Charlie" McCullough (third row, fifth from left), Tom Baker (third row, fourth from left), Jim Leutze (second row, third from left—he later became the chancellor of the University of North Carolina, Wilmington), Lt. Lucky Jordan (first row, far left), Mitch Maiorana (first row, second from right), and Sgt. George Schoepf (second row, far right—just back from the military) with Captain Craig behind. (Courtesy the Robert S. Craig collection.)

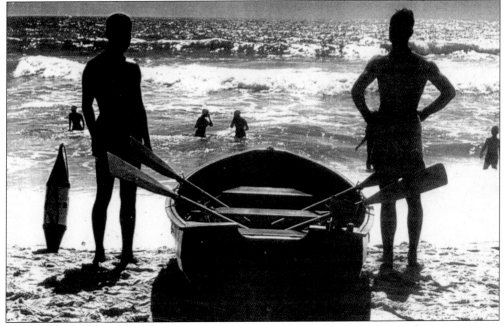

By the late 1950s, the lifeguard with a torpedo buoy had proved his worth in surf rescues in terms of speed and efficiency in getting to a swimmer in distress. This photograph by Robert S. Craig was posed for publicity, but it was the torpedo buoy at left, not the rescue boat, that continued as standard OCBP equipment into the 1960s and beyond. (Photograph by Robert S. Craig.)

In 1958, Captain Craig's elder son, James, turned 16 and joined the beach patrol, serving through 1962, mostly on Fifteenth Street. In 1960, James's younger brother (the author) was tested by Lt. Mitch Maiorana and accepted on the patrol, serving six seasons through midsummer 1965. All three Craigs are shown here on the author's Eighth Street stand near the Lankford Hotel. (Author's collection.)

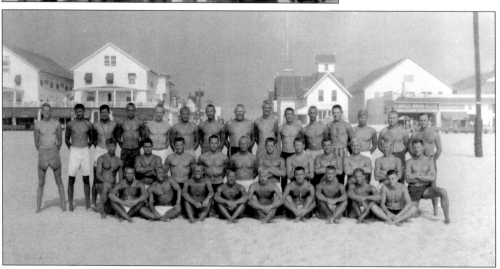

Raymond Knowles (OCBP 1958–1965) was promoted in 1959 to lieutenant—a position he retained for seven years. In this 1959 photograph, Knowles (third row, third from right) is next to the captain's son Jim (fourth from right). The other lieutenant was Mitch Maiorana (first row, fourth from left). George Schoepf (second row, far right) was named sergeant. Captain Craig is also pictured (third row, center). (Courtesy the Robert S. Craig collection.)

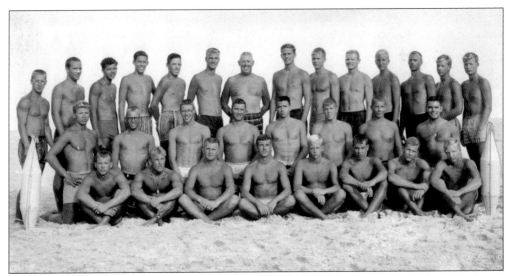

Three Craigs are in the back row of the 1960 OCBP annual photograph: Robert M., James R., and Robert S. (fourth, fifth, and seventh from left). Lieutenants Mitch Maiorana and Ray Knowles are standing at far left and far right respectively. During the late 1950s and early 1960s, George Schoepf lived in Pennsylvania and worked sometimes only weekends until he moved to Salisbury in 1965. (Courtesy the Robert S. Craig collection.)

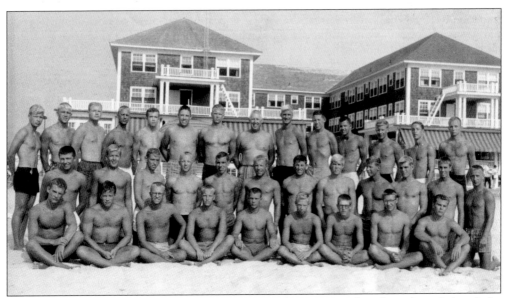

The year 1961 was the final year on OCBP for Mitch Maiorana (kneeling, far right) and the rookie year for Charles "Dutch" Ruppersberger (second row, second from left). After five years on OCBP, Dutch pursued a noteworthy political career including service as CEO of Baltimore County and multiple terms representing the Second District of Maryland in Congress. (Courtesy the Robert S. Craig collection.)

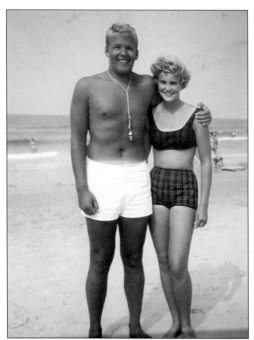

Dutch Ruppersberger and his future wife, Kay, are on the beach in Ocean City. Dutch guarded Sixth Street during several summers when the author guarded Eighth, so they covered for each other, periodically sharing rescues of multiple swimmers in distress. (Photograph by Robert S. Craig, courtesy Congressman Ruppersberger.)

In Anita Ferguson's article "Lifeguard Alums Reunite in Resort" in the October 27, 2000, *Ocean City Today*, Dutch Ruppersberger, pictured with Captain Craig at the first annual lifeguard reunion in 2000, is quoted, "I have great memories of the beach patrol. . . . It was a tough job, and you had to be in shape. But I loved it. And Captain Craig taught me so much about leadership." (Author's collection.)

During the 1960s, the bands Captain Craig selected for the annual lifeguard dance reflected the changing tastes in popular music of the day, from the big band sounds of Les Elgart (1956) or Ralph Flanagan (1959) to rock and roll. Ben Proctor, an OCBP lifeguard from 1961 to 1965, was the drummer for the Lafayettes, a Baltimore band whose 1962 hit song "Life's Too Short" was popular about the time the Lafayettes played the OCBP lifeguard dance. When a young Bob Craig was moonlighting from his lifeguard duties as doorman at the Pier Ballroom in the late 1930s, Ella Fitzgerald was headlining. By 1962, the lifeguard dance featured The Hot Nuts, and the final lifeguard dance in 1965 presented Wilson Pickett. In 1973, the pier ballroom closed as a dance hall. (Right, photograph by Robert S. Craig; below, courtesy Ben Proctor.)

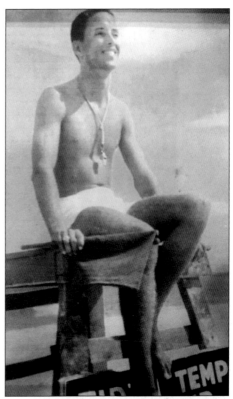

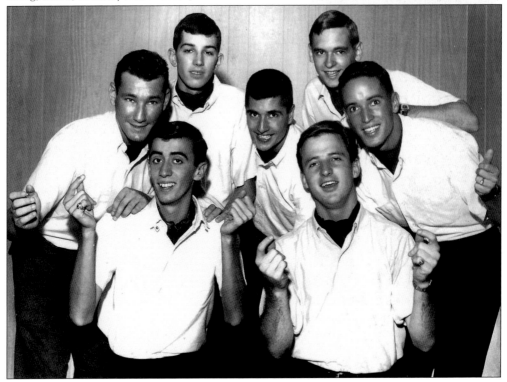

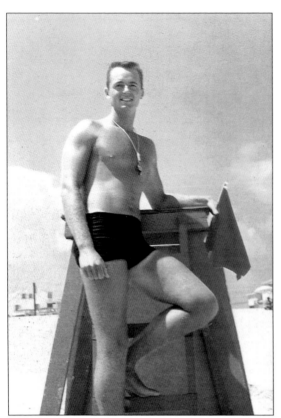

The year 1963 was Warren Williams's rookie year on the Ocean City Beach Patrol. He would serve for 40 years. In 1970, Williams, an engineer, began working at the NASA facility at Wallops Island, close enough to Ocean City that he could work weekends on the patrol during the summers. In Anita Ferguson's article "OCBP Quartet Enjoys Longevity: OCBP Veterans Boast More Than 100 Years," Lieutenant Williams, pictured below with Captain Craig in 2000, comments," "I really enjoy watching the young people develop and gain confidence. The beach patrol is a fantastic place to build character. The lifeguards learn what responsibility is, and how to achieve goals, things that will last throughout their lives." (Both, courtesy Sean Williams.)

Lt. Warren Williams, astride his beach patrol quad in 1999, poses with his grandson Parker (above). His son Sean, photographed with Williams at a beach patrol event in 1983 (below), was a rookie that year, hired by Captain Craig, who had also hired the senior Williams 20 years earlier. Sean would be promoted to crew chief (Crew No. 3) in 1985, and, under Capt. George Schoepf, to sergeant in 1988 and lieutenant in 1990, serving until 1993. (Courtesy Sean Williams.)

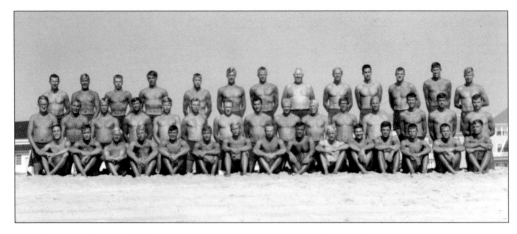

In addition to Warren Williams, two other rookies from 1963 would become officers later in the decade and play major roles as trainers of junior lifeguards—John Jarvis and Bobby Wagner. The training photograph below shows George Chester and Bobby Wagner rescuing John Jarvis. In the group photograph above from 1964, Jarvis is third from left in the third row and Wagner is third from right in the first row. Vic Sprecher (sixth from right, second row) was later instrumental in establishing the city and county beach patrols at South Padre Island, Texas. The author is in the third row, second from right. Lieutenants George Schoepf (far left) and Ray Knowles (far right) are also in the third row, with Captain Craig sixth from right. (Above, courtesy the Robert S. Craig collection; below, courtesy Robert Wagner.)

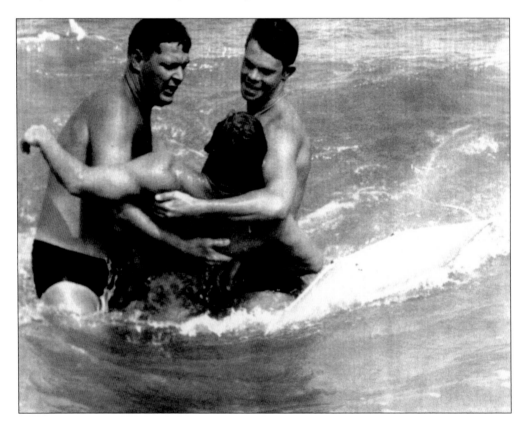

In 1965, Ocean City's town limit was extended to the Delaware state line, and Captain Craig began one of the most difficult summers of his career as head of the beach patrol. With little warning, Craig was asked to double the size of the patrol, from about 43 in 1964 to 88 in 1965. No part of the new "north beach" could remain unprotected, but there were no extra life guard stands, torpedo buoys, semaphore flags, or junior-officer staff in place to cover this substantial increase in scale. That year, 59 of the 88 lifeguards were rookies, and soon Craig discovered he had a rogue lieutenant on his hands. Ray Knowles, a veteran lifeguard since 1958, had convened a meeting of selected lifeguards in what appeared to be an effort to get Craig fired. (Both photographs by Robert M. Craig.)

Some veteran guards were not happy in 1965 when many first-year guards were being paid at the same rate as experienced guards, an established practice since the beach patrol's formation in 1930. A new guard is just as responsible for saving lives as an old guard, Craig insisted, and he knew that soon the north beach would be as crowded as beaches in the older parts of town. The entire nine miles was protected that first summer (although guards were spread thin), and development arrived faster than anticipated; within a dozen years, the skyline of condo row was fully formed. As for the mutiny crisis, Knowles and others disloyal to the patrol were simply not invited back in 1966. (Above, photograph by Robert M. Craig; below, photograph by R.C. Pulling, courtesy the Fisher collection.)

Robert M. Wagner joined the beach patrol in 1963 and served through 1968. Captain Craig and George Schoepf are pictured below in 1966 with their new lieutenant, Wagner. Schoepf had just moved permanently to Salisbury, Maryland, when he called Wagner to detail the new organization of the beach patrol that he and Captain Craig had worked out. Schoepf would return to the patrol as assistant to the captain, and a cadre of four new lieutenants and four sergeants would be appointed, including Wagner as lieutenant. Lieutenants would rotate supervision over various beaches, rather than be assigned a permanent beach, in order to avoid any machinations like the Knowles affair on middle beach. Wagner was asked to reside in the lifeguard barracks to "babysit" the former Coast Guard station, which OCBP was providing as housing for lifeguards. (Both, courtesy Bobby Wagner.)

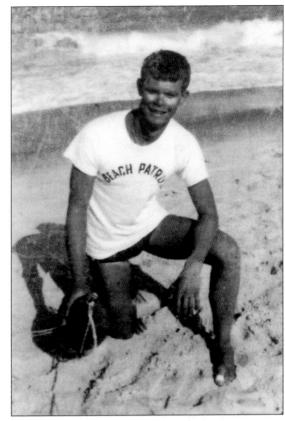

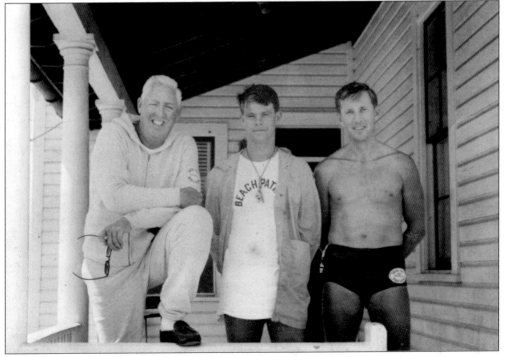

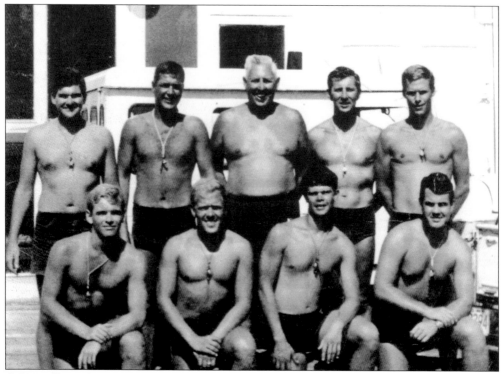

OCBP officers for 1967 include, from left to right, (kneeling) Sgt. Thomas Woodrow Wilson "Woody" Ward, Lt. Latham "Beetle" Morris, Lt. Bobby Wagner, and Sgt. Henry Vinyard; (standing) Lt. Steve Hilbert, Lt. George Chester, Capt. Robert S. Craig, Asst. Capt. George Schoepf, and Sgt. Bob Schaller. Sgt. John Jarvis was absent. (Courtesy Bobby Wagner.)

Bobby Wagner, pictured here training four rookies in the use of the torpedo buoy, once admitted that his "scariest moment was when I had to break holds with Captain Craig [during Wagner's qualification test]. You had to prove yourself to him, that you could rescue a man his size. Craig was a giant to [me] and others." But he was also "our mentor." (Courtesy Bobby Wagner.)

Captain Craig knew he had to evaluate the character and leadership potential from a pool of mostly new guards in order to select his junior officers. Two rookies from the 1965 class characterize the promotion path: Chip Dashiell (right) was assigned his first beach so far north he thought he was in Delaware; then, he guarded in front of the Castle in the Sands Hotel for three years. In 1970, he became a sergeant and was promoted to lieutenant in 1971–1972. Wayne "Bru" Brubaker (below), also a rookie in the expansion year of 1965, guarded Sixth Street, was advanced to sergeant in 1969, and served as a lieutenant from 1970 to 1972. (Right, courtesy Charles "Chip" Dashiell; below, courtesy Wayne "Bru" Brubaker.)

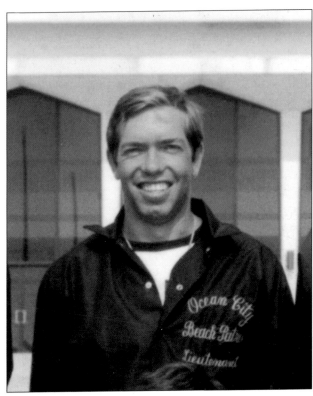

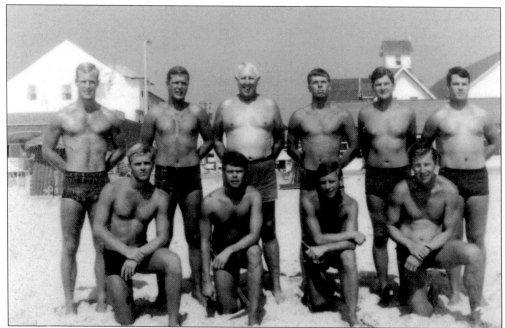

The officers of 1968 include, from left to right, (kneeling) Woody Ward, Bobby Wagner, John Swivel, and Asst. Capt. George Schoepf; (standing) Gerry Garey, George Chester, Capt. Robert S. Craig, John Jarvis (whom Wagner considered one of the top trainers of lifeguard rescue skills), Steve Hilbert, and Henry Vinyard. (Courtesy Bobby Wagner.)

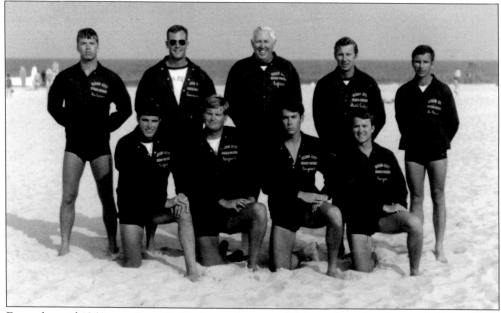

From the mid-1960s on, Captain Craig sought to establish uniform beach patrol attire, which during this period was predominantly navy blue in color and included, as evidenced in this 1969 officer photograph, lightweight jackets. From left to right are (kneeling) Sgts. Billy Troy, George Croker, Wayne Brubaker, and Doug Cassell; (standing) John Jarvis, Gerry Garey, Robert S. Craig, George Schoepf, and John Swivel. (Courtesy Wayne Brubaker.)

Encouraged by George Schoepf, who appreciated the value of smaller teams in encouraging competition as part of physical training, a lower echelon of the patrol's organization was established around 1969–1970. Mark McCleskey's c. 1972–1973 photograph at right of Crew 8 (Forty-Third to Fifty-Third Streets) includes, from left to right, (bottom) Pete Stuart, Mark McCleskey (crew chief), and Peter Edelman; (top) Carlos Ugarte from Chile, John O'Brien, J.P. McGillan, and Tom Kemp. As seen in Tom Cane's 1974 Crew 2 photograph below, crew chiefs wear a distinctive dark blue, black, or grey T-shirt, the latter a consequence of color fading as well as periodic change in style. (Right, courtesy Mark McCleskey; below, courtesy the Robert S. Craig collection.)

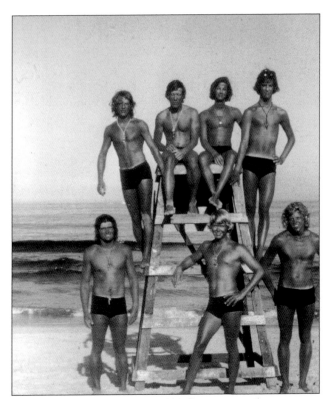

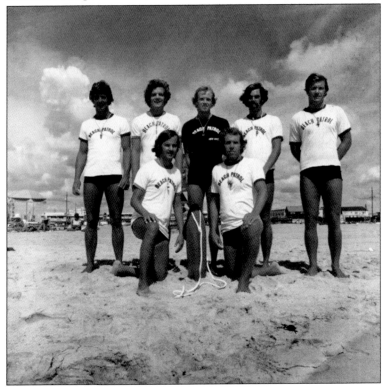

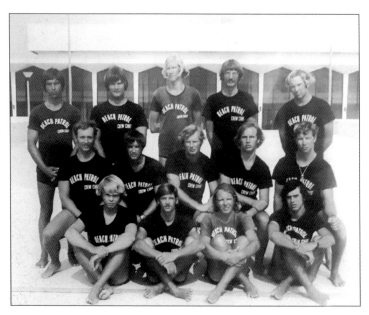

Hair length was always an issue for Captain Craig. But following the Beatles' appearance on *The Ed Sullivan Show* in 1964 and the premiere on Broadway of *Hair: The American Tribal Love-Rock Musical* in 1968, it appears from the 1972 official OCBP crew chiefs photograph and its display of hair that the captain had given up. (Courtesy Mark McCleskey.)

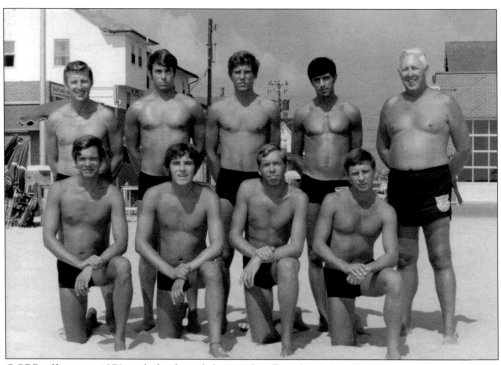

OCBP officers in 1970 include, from left to right, (kneeling) Sgt. Ken Esmark, Sgt. Bill Troy, Sgt. Chip Dashiell, and Lt. John Swivel; (standing) Asst Capt. George Schoepf, Lt. Wayne "Bru" Brubaker, Sgt. Pete Callegary, Sgt. Bob Ferguson, and Capt. Robert S. Craig. John Swivel's claim to fame was being the officer who tested Melbourne "Butch" Arbin in 1972, clearing his way to his rookie year in 1973. (Courtesy Wayne Brubaker.)

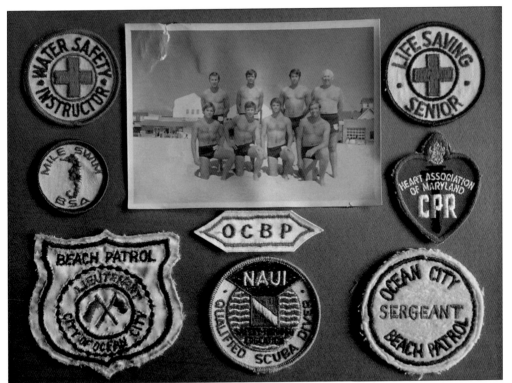

William Wayne "Bru" Brubaker's collection of patches is displayed with a photograph of OCBP officers in 1971. They are, from left to right, (kneeling) Bruce Pelto, John Swivel, Bob Shepanek, and Chip Dashiell; (standing) George Schoepf, Kenny Esmark, Wayne "Bru" Brubaker, and Captain Craig. (Courtesy Wayne Brubaker.)

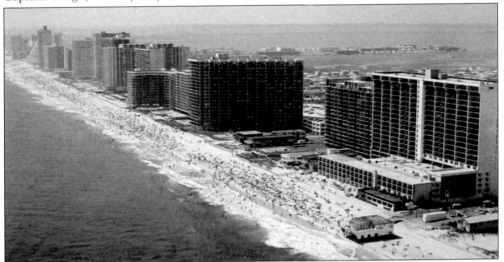

By the end of the 1970s, Condo Row stretched from the massive slab of the 9400 building to the Carousel (foreground), whose 1961–1962 motel was enlarged in 1974 with an expanded 237-room hotel, a new 22-story, 190-condo tower, and an architectural scale more in keeping with the 1970s. The new Carousel was Ocean City's first multiuse mega-structure. (Photograph by R.C. Pulling, courtesy the Fisher collection.)

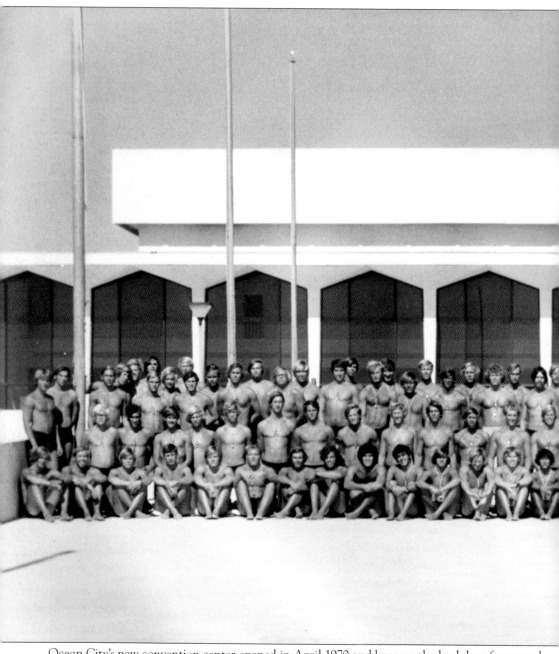

Ocean City's new convention center opened in April 1970 and became the backdrop for several years for the annual OCBP photographs. The patrol in 1971 had grown demonstrably since the

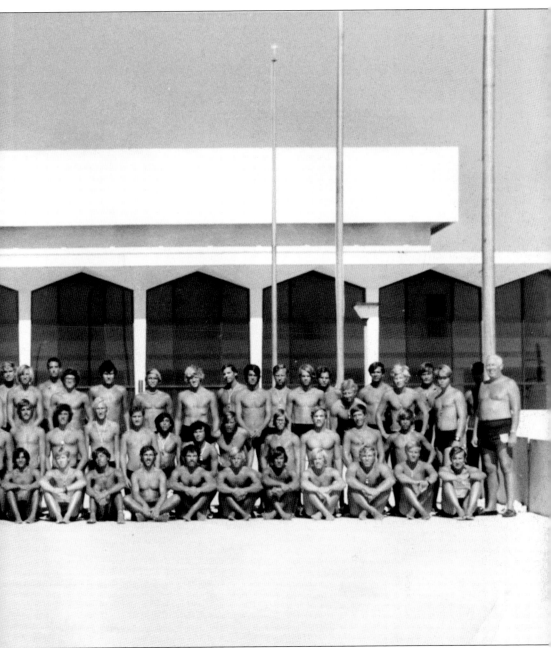

1965 expansion of city limits to 146th Street (Delaware state line). The 1964 patrol of 43 men contrasts with the gathering here of 102 men, but still no women. (Courtesy OCBP.)

In 1957, an advertisement appeared in the lifeguard dance booklet asking, "Why not Women Lifeguards?" Beginning in 1972, women signed up for the qualifying test but "self-disqualified" by not showing up. Then, in 1978, Susan Cain entered "horribly cold" water, tested, was "so exhausted at the end of the day," but said, "I really wanted this," and passed. Her new crew chief gave her no special treatment: "He needed a fit crew and I needed to fit the standard. It hit me that this is a job that women could do, and I can't mess it up for other women." When her crew dyed their swim caps pink for the annual crew competition, Cain knew she had been accepted. The lifeguard on the stand at left is Jenny Webb in 2011. (Above, courtesy OCBP; left, photograph by Jim Crowley.)

By the mid-1980s, female open-water lifeguards were growing in number (this photograph from 1983 shows OCBP lifeguards clowning around before an official photo shoot). A 1986 *American Lifeguard* magazine article described the first annual all-women's lifeguard competition held in 1985 "to encourage this nontraditional line of work for women." By 2016, there were 45 women among the 180 OCBP members. (Courtesy OCBP.)

Pat Carey became the first OCBP female officer. Hired in 1980, she guarded the 136th Street beach, became a crew chief in 1983, and was promoted to sergeant in 1985. (Courtesy the Robert S. Craig collection.)

Captain Craig witnessed the emergence of surfing as a popular sport in Ocean City waters and negotiated the establishment of surfers' beaches, initially (1971–1975) between 94th and 118th Streets. Surfing was perceived as dangerous to swimmers in crowded areas and not permitted elsewhere other than before and after the hours lifeguards were on duty. As development along condo row increased, surfing was disallowed as soon as a property was issued its certificate of occupancy, the last closing out the surfing area entirely by 1980. Finally, in the mid-1980s, a rotating system was created with two sections, one north and one south, shifting daily as designated surfing beaches, so no property owner had to limit swimmers for more than a day. In 1990, under George Schoepf, OCBP established surf rescue facilitators to supervise the rotating beaches. (Both photographs by Robert J. Banach.)

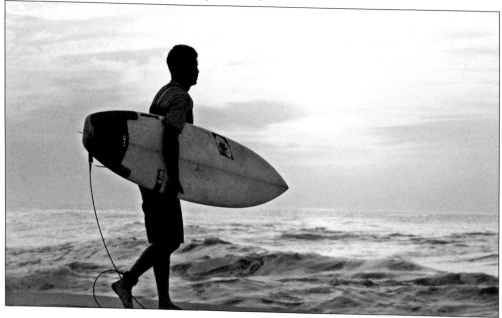

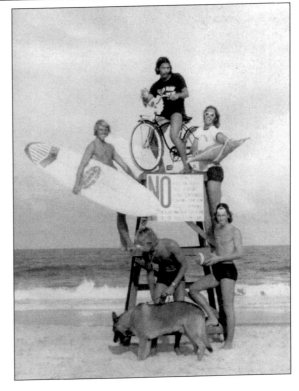

ROTATING SURFING BEACH
NO SWIMMING OR WADING
TODAY ONLY

Signs were posted to indicate the day's surfing beach, within a designated area that shifted one block to the south each day. OCBP published a surfers' beach schedule defining areas on north and south beaches; in 2007, the south end of the beach between the pier and inlet started to allow surfing daily. (Author photograph.)

OCBP SRTs pose to illustrate what is disallowed on the boardwalk and beach: no bicycles after 10:00 a.m., no tampering with lifeguard equipment, no surfing, no ball playing in crowded areas, and no dogs allowed. (Courtesy OCBP.)

Also during the late 1970s, OCBP inaugurated annual intramural crew competitions (1976), began participating in the Rehoboth Lifeguard Olympics (1978), and soon emerged as a regional leader in the newly incorporated (1979) United States Life Savings Association (USLA). (Courtesy the Robert S. Craig collection.)

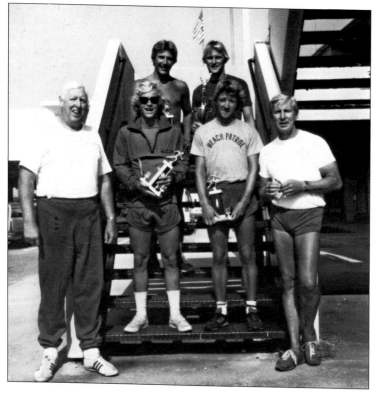

Captain Craig (left) and Assistant Captain Schoepf flank four OCBP trophy winners returning from the 1982 Lifeguard Olympics at Rehoboth Beach (five first-place wins and overall team winner): Steve "Sony" Nelson (OCBP's beach flags champion and part of first-place soft sand run relay team, left), Frank Sharkey (first in two-mile run, right), (Charlie "Chazz" Chiamardas, top left), and Bruce Silvano (first in ironman competition, top right). (Courtesy Chazz Chiamardas.)

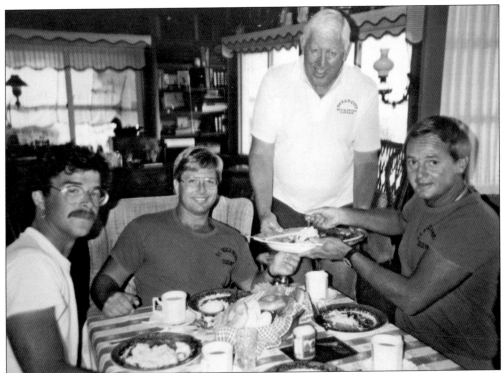

In June 1981, Captain Craig retired from teaching at Principia and returned to Ocean City to live year-round. For many years, Ginny and Robert S. Craig sponsored periodic officers' breakfasts at the summer cottage, Bay Breeze, a tradition that continued at their year-round home. One of the last such officers' gatherings included (below, left to right) Tom Perry, G.W. Mix, Captain Craig, Asst. Capt. George Schoepf, Eddie Jordan, Hugh Hommel, Tom Carey, Butch Arbin, Warren Williams, and Pat Carey, seated in front. At table above from left to right are Hugh Hommel, Tom Perry, and Warren Williams, with the captain serving. (Both, courtesy the Robert S. Craig collection.)

As Captain Craig contemplated retirement from the beach patrol, selection of junior officers to lead the patrol into the future became a responsibility he took seriously, and he was proud of the leaders who emerged (see page 77, bottom image). Craig had hired George Schoepf in 1950 and Butch Arbin in 1973; others, not yet officers but soon to be promoted by Craig's successors, were Skip Lee, Ward Kovaks, and Mike Stone, hired in 1982, 1983, and 1984 respectively. The 1986 OCBP photograph below illustrates the extent of the beach patrol at the time of Craig's retirement. (Above, courtesy Swimspire; below, courtesy OCBP.)

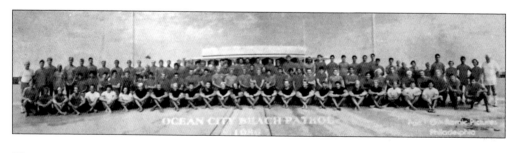

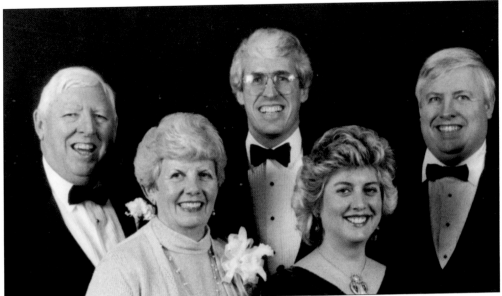

In the fall of 1986, Ocean City celebrated the career of Capt. Robert S. Craig by hosting a grand ball gala in his honor. Captain Craig's family doffed swim attire in favor of formal attire for this photograph. From left to right are Captain Craig; his wife, Virginia; his son Rob (author); Rob's wife, Carole; and the captain's eldest son, Jim. (Author's collection.)

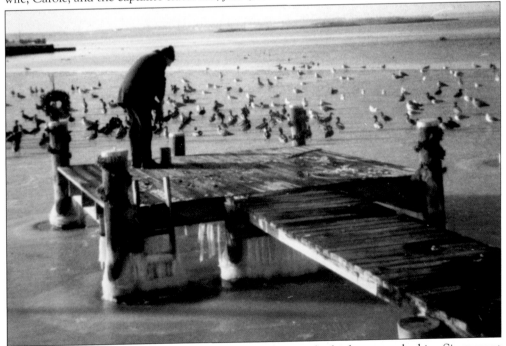

Captain Craig spent the last 22 years of his life happily retired at his home overlooking Sinepuxent Bay, feeding his ducks, and welcoming countless visitors, including former lifeguards, as well as journalists who interviewed the man they considered a legend of lifesaving. Throughout the interviews, the captain played his old vinyl recordings of Glenn Miller and Erroll Garner. (Courtesy the Robert S. Craig collection.)

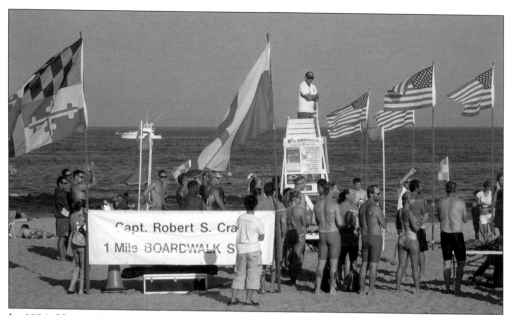

In 1984, Harvey Evans (OCBP 1978–1982) was elected president of the newly formed OCBP chapter of the United States Lifesaving Association. Eleven years later, he would be instrumental in inaugurating the Robert S. Craig one-mile boardwalk swim held each year on the weekend closest to the former captain's July 11 birthday. The event celebrates its 25th year in 2019. Below, Captain Craig (far left) and Harvey Evans (second from right) pose with the inaugural 1995 Craig swim men's and women's division winners, Brian Davis and Cineva Kline. (Above, photograph by Robert M. Craig; below, photograph by Missy Evans, courtesy Harvey Evans.)

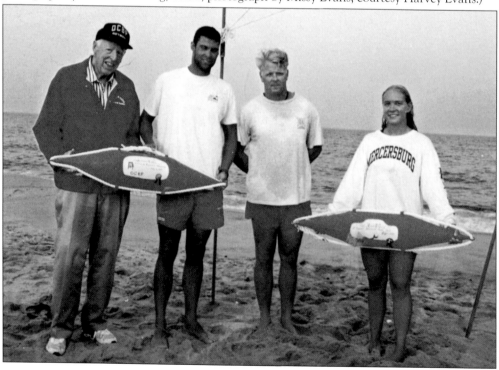

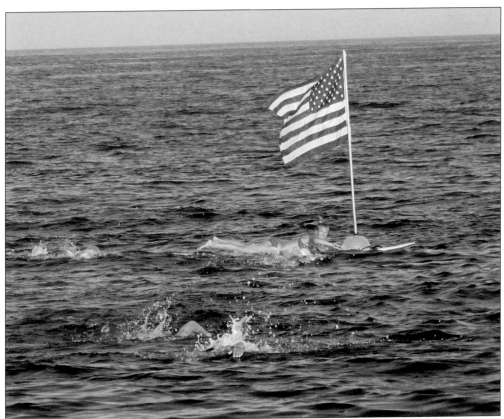

Safety personnel on surfboards and buoyed flags guide packs of swimmers in the Robert S. Craig One-Mile Swim. For many years, through 2017, a quarter-mile swim was also sponsored on the same day in honor of Captain Craig's wife of 68 years, Ginny. For several years, Peter Galen and his sister Julia participated, with Peter winning the men's division in 2013 and 2014 and placing second in 2015, and Julia placing second in the women's division in 2014 and winning it in 2015. Julia Galen is the founder of Swimspire, a coaching and swimming news source providing private lessons, customized workouts, instructional videos, and remote coaching worldwide. (Above, photograph by Robert M. Craig; right, courtesy Swimspire.)

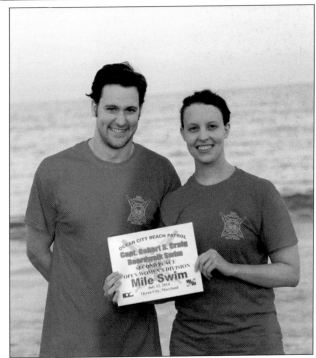

At the end of the summer of 1998, Captain Craig's grandson Christopher surprised his grandfather with the news that he had just passed the qualifying test to become a lifeguard. In subsequent years, he was pictured (above, far right) on an OCBP promotional brochure. Christopher would serve from 1999 to 2001, the first third-generation member of the Ocean City Beach Patrol. Local newspapers soon learned of this historic event, and promptly posed the new lifeguard with his father and grandfather for what became known as the "three generations" photograph. (Above, courtesy OCBP; below, photograph by Anita Ferguson, courtesy OC *Today*.)

The new millennium opened with the first triennial lifeguard reunion, organized by Ells Boyd (above left, with Charlie Austin), whom Captain Craig first hired in 1951, and who in recent years had published numerous articles about the beach patrol and its captain. The inaugural reunion invited lifeguards from the 1940s, 1950s, and 1960s (subsequent reunions included later decades as well). In 2007, Boyd organized the third reunion, Legends of Life Saving, again inviting OCBP alumni to celebrate their beach patrol experiences and to renew acquaintances, especially with their former captain. Captain Craig attended the first three reunions, in 2000, 2004, and 2007. (Both, courtesy the Robert S. Craig collection.)

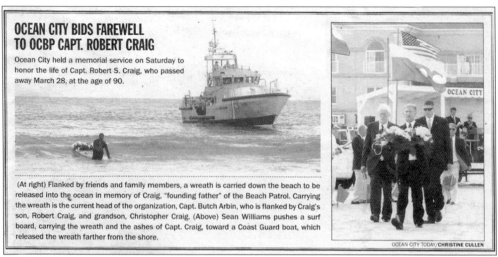

OCEAN CITY BIDS FAREWELL TO OCBP CAPT. ROBERT CRAIG

Ocean City held a memorial service on Saturday to honor the life of Capt. Robert S. Craig, who passed away March 28, at the age of 90.

(At right) Flanked by friends and family members, a wreath is carried down the beach to be released into the ocean in memory of Craig, "founding father" of the Beach Patrol. Carrying the wreath is the current head of the organization, Capt. Butch Arbin, who is flanked by Craig's son, Robert Craig, and grandson, Christopher Craig. (Above) Sean Williams pushes a surf board, carrying the wreath and the ashes of Capt. Craig, toward a Coast Guard boat, which released the wreath farther from the shore.

OCEAN CITY TODAY/CHRISTINE CULLEN

Capt. Robert S. Craig passed away on March 28, 2009. In April, family, friends, and lifeguards past and present remembered him in a moving memorial service on the beach. Lucky Jordan (OCBP 1945, 1950–1955) and Charlie Austin (OCBP, 1949–1953) represented former lifeguards. Current captain Butch Arbin presented the eulogy followed by remarks by US congressman Dutch Ruppersberger, local officials, and a representative from the US Lifesaving Association. While a soloist sang "Eternal Father, Strong to Save," the hymn about those in peril on the sea, Captain Craig's son (on stand) and grandson (with flags) semaphored a farewell message to the lifeguards gathered around a lone lifeguard stand. Sean Williams then carried a memorial wreath and the captain's ashes by surfboard to an awaiting Coast Guard boat. The boat sounded its horn in tribute, turned, and sailed seaward. (Above, courtesy OC *Today*; below, courtesy OCBP.)

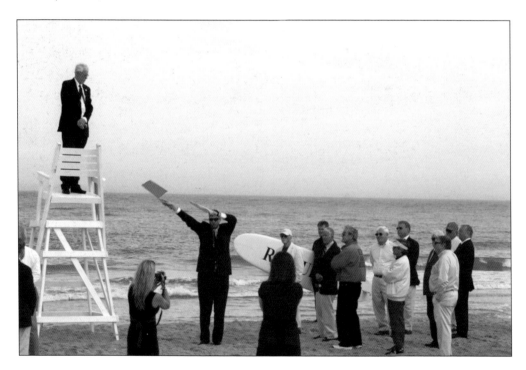

In 2018, the US Department of the Interior listed the Craigs' summer cottage, Bay Breeze, in the National Register of Historic Places in recognition (among other areas of significance) of the building's historic role as the home of the patriarch of the beach patrol. In a ceremony unveiling the bronze plaques, former Ocean City mayor Jim Mathias and the then current mayor Rick Meehan spoke, and the captain's grandson Christopher Craig read a citation from Congress. Pictured at right are, from left to right, former lifeguards Bobby Wagner, Christopher Craig, Robert Craig, and Chip Dashiell. Below, from left to right, are Capt. Butch Arbin, Kristin Joson, Christopher Craig, Robert Craig, and Brent David Weingard. (Both, author's collection.)

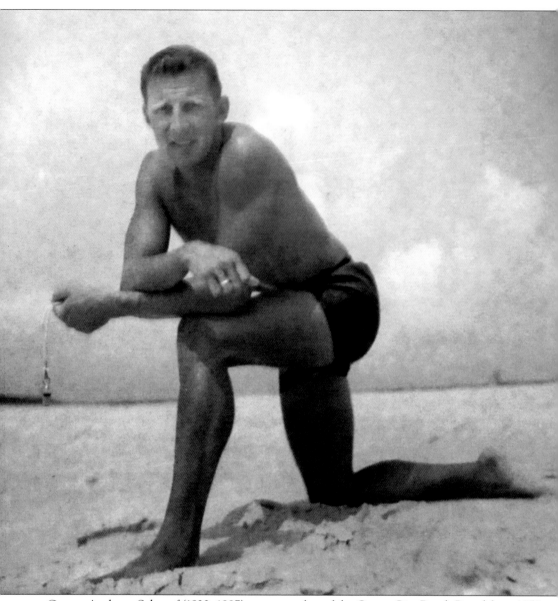

George Anthony Schoepf (1930–1997) was a member of the Ocean City Beach Patrol from 1950 to 1997, serving longer (as of this writing) than anyone else except Captain Craig. Schoepf was the embodiment of the lifeguard as physically fit athlete, sported an engaging smile, and was an exemplary coach, always with an eye on improving the competitive edge that his enthusiastic urging might provide the well-trained professional. (Photograph by Robert S. Craig.)

Three

THE GEORGE A. SCHOEPF ERA

Capt. George Schoepf was a coach and physical fitness trainer whose venue was swimming and lifesaving, and whose personality and organizational talents were characterized by competition, loyalty, and camaraderie. He supported and advanced the beach patrol's quasi-military organizational structure, understanding that teams created teammates as well as competitors, and he viewed himself as chief mate, counselor, and, where productive, "one of the boys." His lifeguarding career with the Ocean City Beach Patrol extended for almost half a century, from his rookie year in 1950 until his too early death in 1997. During that time, his longest service was as assistant to the captain, but his role evolved under Captain Craig to something akin to an executive officer. As the patrol grew in numbers and complexity, and as Captain Craig was forced by the sheer scale of administrative activities to relinquish his personal testing and training of lifeguard candidates, Schoepf's considerable talents as a coach and physical trainer brought him into more direct contact with the lifeguards on the beach. Schoepf insured that the newly expanded nine miles of shoreline were covered, that lifeguards remained fit and skilled, and that the town's outstanding safety record remained untarnished.

Schoepf thrived on lifeguard competitions—intramural, regional, and national—and continued to compete himself on occasion. When he became captain in 1987, Ocean City had already hosted several Mid-Atlantic Regional Lifeguard competitions, had sent teams to national USLA competitions, and had been conducting crew competitions, at his urging, since 1976. Cheerleading every team he mounted, Schoepf remained essentially a creator and coach of the newly dubbed "surf rescue technician"; he dressed like his boys, in OCBP's uniform swim attire; and he was able to say "I have your back" at the same time that he was always on your back, demanding optimal performance. When Schoepf observed an administrative and organizational skill in a junior officer, he cultivated it, in order to avoid becoming desk-bound and to allow himself to remain on the beach as a proactive supervisor and lifelong participant in lifeguard work.

George Schoepf's grandfather was from Heidelberg and a graduate of Heidelberg University; his only son, Lawrence, George's father, lived in Philadelphia, establishing Schoepf roots in Pennsylvania. Before moving in 1965 to Salisbury, Maryland, George lived in Bedford, Pennsylvania, where he was appointed assistant football coach in 1956, two years after this photograph was taken. He married Joannie Conrad, and they had three children—Greg, Sherry, and Kerry Lynn Schoepf. (Courtesy OCBP.)

George Schoepf's rookie year was 1950, and when the patrol acquired a rescue boat the following year, Schoepf took an interest in that dimension of the patrol. In this 1952 publicity photo taken on Seventh Street, Schoepf (left) helps Wade McClusky (right) and Jerry Isear launch the boat. (Photograph by Robert S. Craig.)

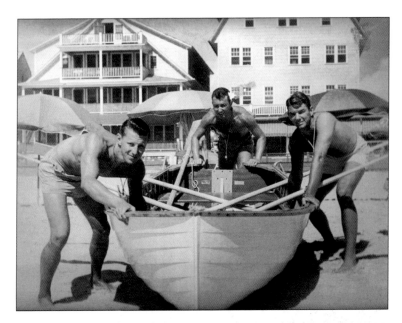

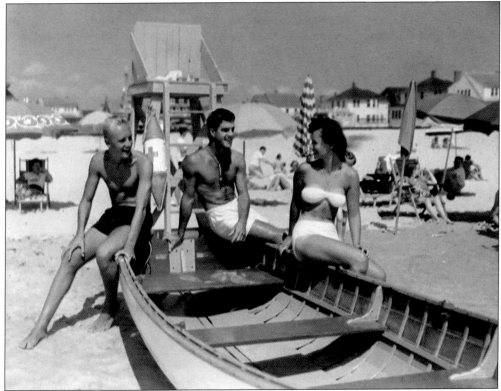

Wilson Fewster (center), pictured in another 1952 publicity photo, joined the patrol in 1943, serving through 1952 (other than 1945–1946). By 1951, he was listed as assistant captain, although not in 1952; no officers are identified in 1952 or 1953. In 1954, there were three sergeants and two lieutenants, so when Schoepf returned from the military in 1954, he was promoted to the rank of lieutenant. (Photograph by Robert S. Craig.)

Following two years of active military service in 1953–1954, Schoepf returned to Bedford, Pennsylvania, to begin his coaching career there, working some summers and sometimes only weekends on the OCBP until 1965. Records indicate his rank as sergeant in 1959 and lieutenant in 1955–1957 and 1962–1965 (1958 rank unknown). He became assistant to the captain in 1966 and remained so for 21 years. (Courtesy the Robert S. Craig collection.)

Throughout nearly four decades of collaboration, Captain Craig and George Schoepf proved to be an affective team, Craig increasingly delegating day-to-day supervision on the beach to Schoepf, and approving various organizational changes, overseeing training practices, and often delegating the management of competitions to his assistant. (Courtesy OCBP.)

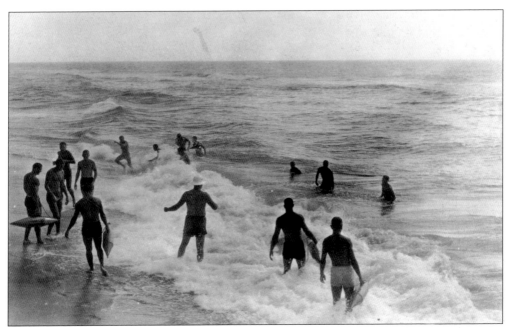

Training of lifeguards under Craig had taken two forms: periodic instructional meetings covering first aid or artificial resuscitation, and "swimming blocks" to remain fit. Beyond that, there were "bad boy swims" in which guards observed by an officer to have broken some OCBP rule would be assigned penalty blocks to swim on Monday morning at 8:00 a.m. So long as the disciplinary penalty was justified, most considered the bad boy swim an adequately benign ploy to ensure maintenance of physical fitness, despite the distaste of early morning wake up calls for overtime without pay. Schoepf sought a means to bring greater focus to teamwork and instill a competitive spirit and team rivalry rather than individual punitive discipline as a means for keeping fit. These photographs record a Craig training session and lifeguard exercise. (Both, courtesy OCBP.)

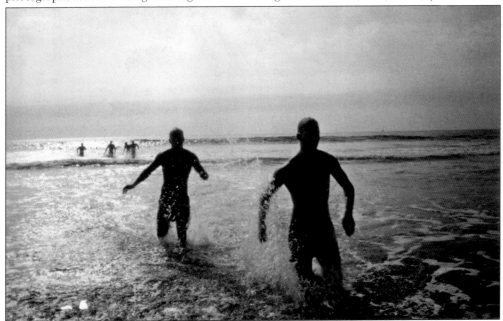

Schoepf's solution for a more sustained and effective physical training program was to create small platoons, or crews, of lifeguards, give each an identity and crew chief, and encourage an intramural rivalry among crews of seven or eight lifeguards each. After the difficult year of rapid growth of the patrol in 1965, he and Captain Craig worked out a reorganization of OCBP calling for four sergeants and four lieutenants, and (at Schoepf's prompting) they then experimented around 1969 with crews supervised by crew chiefs. The photograph of the 1969 north beach crew above, with crew chief Kerry Williams, may be the earliest OCBP crew photograph. In 2008, well after Schoepf's era, Crew 12 arrived at the annual crew competition dressed as Indians (below), confirming Schoepf's belief that the crew structure enhanced team identity. (Both, courtesy OCBP.)

Brent David Weingard was hired by George Schoepf in 1990 and will celebrate 30 years on the patrol in 2019. He is shown here on his lifeguard stand in 1993 and with his crew, when he was crew chief of Crew 4 (Surf Avenue) in 1994. From left to right are Chris Stankis, Brent David Weingard, Ed Fisher, Ron Huggins, Tim Uebel, and Mark Hunkele. (Both, courtesy Chris Stankis.)

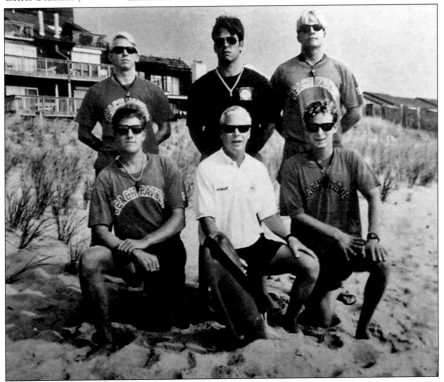

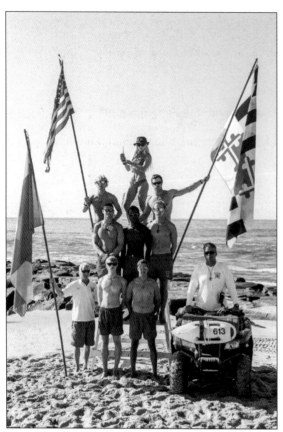

In 2018, Sgt. Brent Weingard sits on an all-terrain vehicle with a jaunty crew photographed creatively by Tom Lurie. The pride that George Schoepf knew was inherently within each individual identified with a crew, was manifested in that sense of camaraderie about which Charlie Austin, a lifeguard from the 1950s, has so often spoken. It was manifested in rivalry at crew competitions but also developed internally a spirit that a guard backs up his crewmate in ocean rescues. Below, in 1983, Crew 3, with crew chief Christopher S. Heimert, was photographed on a rock jetty in an equally distinctive pose worthy of a lifeguard calendar. (Left, photograph by Tom Lurie; below, photograph by Robert S. Craig.)

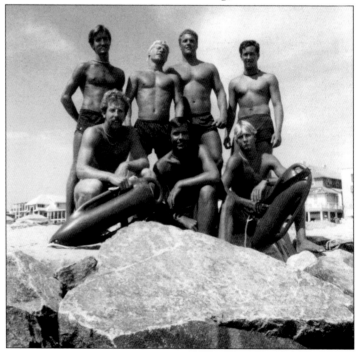

Crew competitions were inaugurated during Captain Craig's tenure but were promoted and initiated by George Schoepf. All the paraphernalia of competitive sport accompanied the intramural competition, including trophies and medals, T-shirts, and most especially bragging rights. (Right, photograph by Robert M. Craig; below, courtesy Sean Williams.)

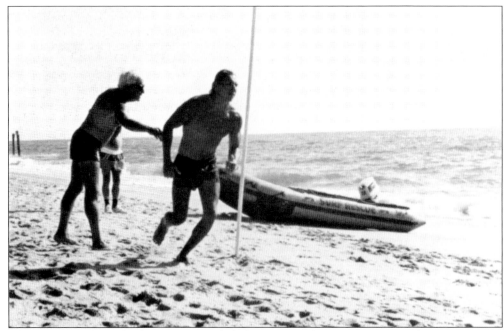

Crew competitions and other contests included running and swimming races and rescue exercises that illustrated skills and abilities of the lifeguards, attracting considerable public attention. Above, a lifeguard is cheered on by George Schoepf at a 1989 contest, while below, a timer checks a runner's time in a qualifying event. (Both, courtesy OCBP.)

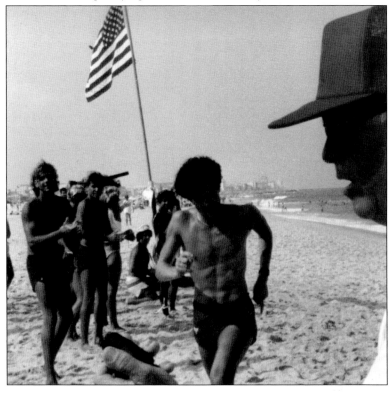

Rope line rescues were part of regional and national competitions, and when victims were hauled ashore on a lifeguard's back, the vigorous exercise and skill attracted onlookers' interest. (Both, courtesy OCBP.)

Above, Steve Nelson, prone in the sand, waits for the whistle to begin his sprint to markers in a "beach flags" elimination race not unlike musical chairs. Nelson competed successfully at the Daytona Beach National Lifeguard Championships in 1982, taking first place in the beach flags event. Below, sand flies as runners dive for a remaining marker upright in the sand. (Above, courtesy Chazz Chiamardas; below, courtesy Dan Cook/*Cape Gazette*.)

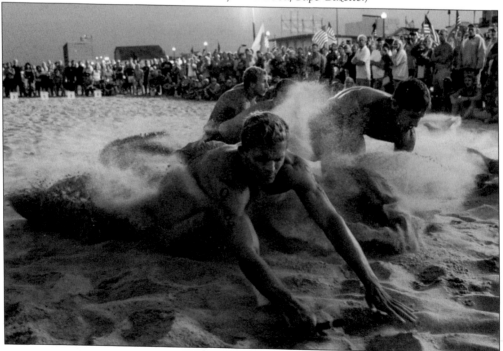

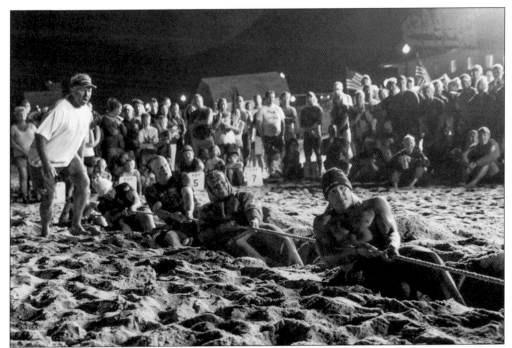

Skip Lee encourages the OCBP tug-of-war team at the Rehoboth Olympics in 2017. At the annual crew comps in 1994, one crew (here, Ron Huggins of Crew 3) was pitted against the other in a series of elimination tugs. A victory in this event was almost as sought after as overall first place. (Above, courtesy Dan Cook/*Cape Gazette*; below, courtesy OCBP.)

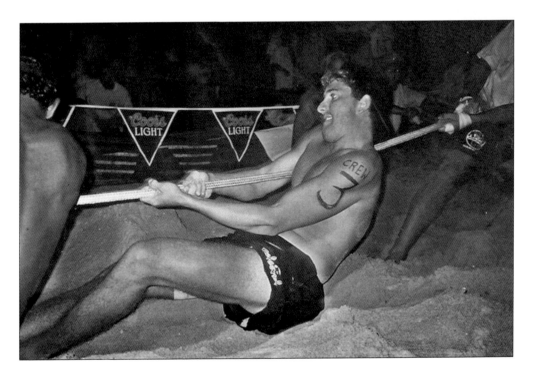

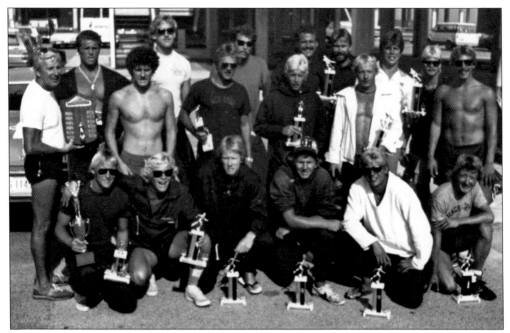

When the United States Lifesaving Association was inaugurated, Captain Craig became an early member and OCBP began to host and participate in regional competitions as a prerequisite to sending competitors to the USLA nationals. Schoepf thus found another venue for training and physical fitness. In 1982 (above), Schoepf poses with the OCBP team that brought home multiple trophies from the Rehoboth Olympics and Mid-Atlantic Regionals. From left to right are (first row) Bruce Silvano, Steve Nelson, unidentified, Skip Lee, Mark Acton, and Frank Sharkey; (second row) Asst. Capt. George Schoepf, Eamon Walls, Lou Balla, Chuck Morrison, Larry Russell, and Charlie Chiamardas; (third row) Rodney Yates, J. Kevin Smith, Dale Hodges, Mike Burke, Mark Warren, Paul Armstrong, and Mark Griffith (black shirt). That same summer (below), Schoepf competed in the Rehoboth Lifeguard Olympics in a veterans/senior division. (Above, courtesy OCBP; below, courtesy Chazz Chiamardas.)

OCBP remained active in regional and national competitions throughout the 1980s, as Schoepf continued to train and prepare OCBP teams. Above, Schoepf is pictured holding the Ocean City town flag with the OCBP team that participated successfully at the 1982 USLA nationals in Daytona. From left to right are Asst. Capt. Schoepf, Charlie "Chazz" Chiamardas, Bruce Silvano, Steve "Sony" Nelson, Frank Sharkey, and Tom Perry. Perry would remain active in the Mid-Atlantic Region of the USLA for years, and currently serves as its vice-president. Below, in 1983, (from left to right) OCBP's Mike Burke, Madison Clarke, Rollin Bell, and Bruce Silvano took first place in the land line competition at the USLA nationals held at Long Beach, New York. The following year, Captain Crag took a team to the nationals at San Clemente, California. (Both, courtesy Chazz Chiamardas.)

The 1983 competitors at the USLA national lifeguard championships in Long Beach, New York, pose behind the rescue board. From left to right are Eamon Walls (from Belfast, Ireland), Asst. Capt. Schoepf, Phil Schoepke, Diane Benedictis, unidentified, Charlie Chiamardas, Frank Sharkey, unidentified, and Bruce Silvano. (Courtesy Chazz Chiamardas.)

In 1986, OCBP sent other successful competitors to the nationals in Galveston, Texas. George Schoepf placed sixth in the thousand-meter swim, veterans division. The winning land line team (OCBP) consisted of, from left to right, Paul O'Brien, Joe Karney, Damon Deppe, and Eddy Jordan. (Courtesy Sean Williams.)

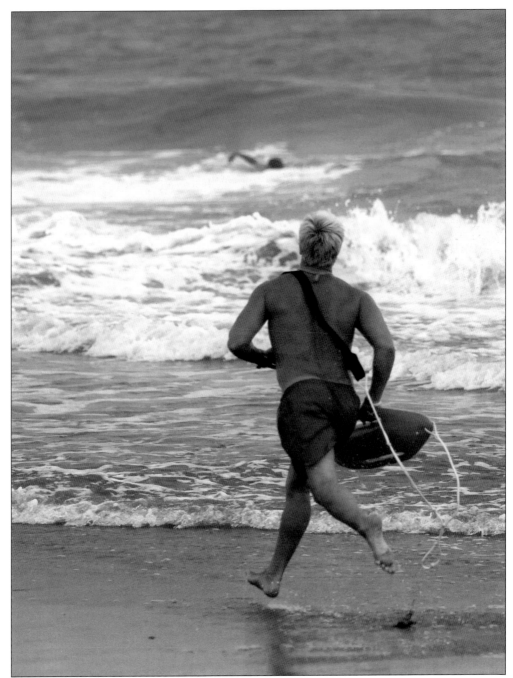

As a career coach and physical fitness expert, Schoepf recognized that competitions require practice and that regular training and workouts develop lifeguards ready for any and all emergencies. In "Ocean City's Finest," an article by Ellsworth Boyd in the July 16, 1972, edition of *Extra: The Magazine of the New American*, Schoepf is quoted: "Prospects don't just apply for a job here. They earn a position, one they can be proud of." The lifeguard seen here is Andrew King (2010–2014) (Photograph by Jim Crowley.)

As Captain Craig neared retirement, everyone assumed that his associate since 1950, "assistant to the captain" George Schoepf, would become the next OCBP captain. For years, lifeguards called him Captain Schoepf, avoiding the "assistant to," although Craig's view was that only he was ultimately responsible for the patrol; his 40 years teaching in Missouri taught him Harry Truman's maxim: "The buck stops here." (Courtesy the Robert S. Craig collection.)

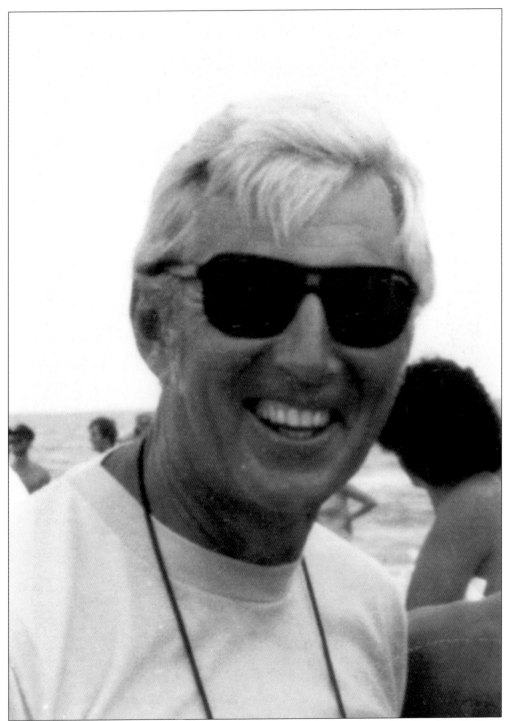

In an undated news clipping, "38 Years on the Patrol," by John Engelman, from a Robert S. Craig scrapbook, Craig also said of Schoepf, "Any success with the beach patrol that I have had has been due to the caliber of the men with whom I have worked, particularly my assistant captain, George A. Schoepf." This photograph of Schoepf is from 1982. (Courtesy OCBP.)

When George Schoepf became captain in the early summer of 1987, the patrol had about 140 members, including four sergeants, four lieutenants, and SRTs organized in about 18 crews of seven or so each. The new title for lifeguards was devised by Schoepf to emphasize their professionalism in open-water ocean rescue. The patrol picture above is from 1988; the 1989 officers below are, from left to right, Lt. Skip Lee, Lt. Butch Arbin, Sgt. Ward Kovaks, Capt. George Schoepf, Sgt. Sean Williams, Lt. Warren Williams, and Sgt. Dave Griffith. Griffith would later become captain of the Sea Colony Beach Patrol. (Both, courtesy OCBP.)

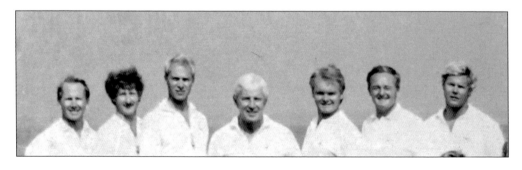

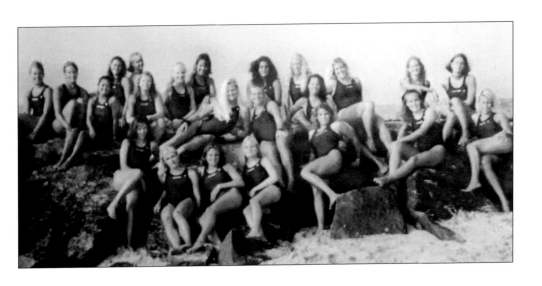

Schoepf continued to hire women, along with men, for the patrol so that by the end of his tenure as captain, there were nearly two dozen female surf rescue technicians working for OCBP. The photograph on the rocks above shows female SRTs on the OCBP in 1997; the rescue board competitors below are from 1996. For various reasons, OCBP's involvement in USLA competitions dissipated during the 1990s, although crew competitions continued. (Both, courtesy OCBP.)

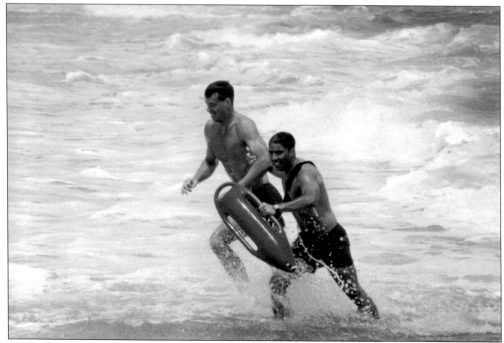

Schoepf pursued his focus on training and conducting practice rescue sessions to hone the skills of his SRTs. In 1993 (below), Ward Kovaks, one of Schoepf's sergeants, trains a surf rescue technician to "break holds," reacting to potential cases when a drowning victim might panic and grab a lifeguard in a stranglehold. Schoepf's favorite quip during rookie training was remembered by 1983 rookie Sean Williams in a May 21, 2018, Facebook comment: "The water today is a BALMY 56 degrees! Y'all get on out there and have a nice swim!" (Both, courtesy OCBP.)

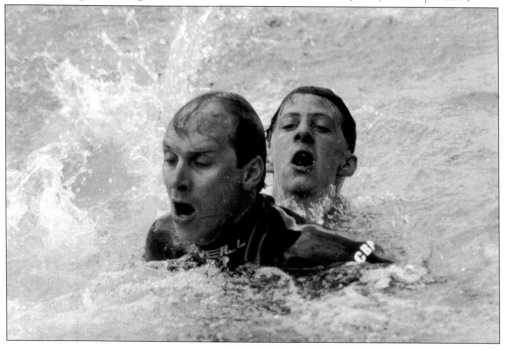

The year Schoepf became captain, telephone lines strung to short poles on the beach were removed, and radios (walkie-talkies) replaced phones, while semaphore continued to be the mainstay of communication. When other new equipment was introduced, additional training sessions were organized and conducted by Schoepf's junior officers, including safe employment of faster beach transportation (all-terrain vehicles, or ATVs) and the proper use of mechanized rescue equipment such as inflatable rescue boats (IRBs) and Jet Skis. Assistant crew chief Adam Grant (2011–2014) is pictured above on an ATV, and Ward Koraks (1983–present) is on the IRB below. (Both, courtesy OCBP.)

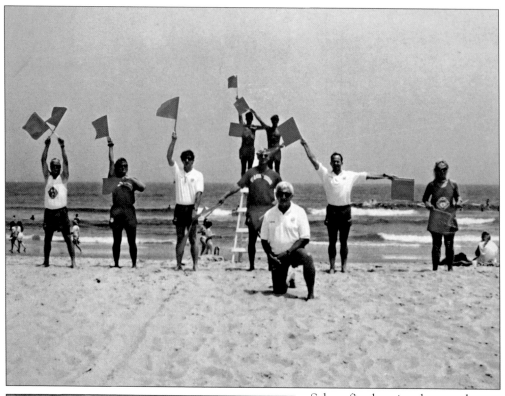

Schoepf's educational outreach included continuing efforts to keep the beach patrol's image and good name in the press. In the above publicity photograph for the local newspaper, Schoepf's surf rescue technicians spell out the paper's name, "OC Today," in semaphore. At left, in 1991, lifeguards Mark Henkle (left) and Dave Griffith appeared with a local model on the cover of *Ocean City* magazine. (Both, courtesy OCBP.)

Schoepf visited elementary and high schools in the area during the winter to teach children about rip currents and water safety and to interest older teens in opportunities for future jobs on the beach patrol. Preliminary qualifying tests were scheduled in local university swimming pools, and "Coach" Schoepf was poolside encouraging potential SRTs to put forth their best efforts. (Both, courtesy OCBP.)

Throughout his tenure as captain, Schoepf had his eye on the past, maintaining connections with lifeguards who served with him in the 1950s, such as Lucky Jordan, seen above with Schoepf during one of Lucky's frequent return trips to the town where his career as a waterman began. The 1991 photograph of Butch Arbin below shows him already skilled in computer technology and maintaining OCBP records. This is a rare image of the interior of the beach patrol headquarters at the time, which occupied the second floor above the Worcester Street/Boardwalk public toilets, where OCBP offices (to the disgust of both Captains Craig and Schoepf) were located for many years after 1972. (Above, courtesy OCBP; below, photograph by Sean Williams.)

When George Schoepf died in June 1997, he was only 67. Butch Arbin, who had been serving as acting captain during Schoepf's illness, was immediately appointed captain. Arbin had already been a member of OCBP for 24 years. The following summer, Arbin initiated the annual George Schoepf Relay, a memorial event in which typically 100 current lifeguards and OCBP alumni, as well as members of the Schoepf family, participate. One by one, runners pass the traditional metal torpedo buoy along the nine miles of beach, and when the buoy reaches the Delaware line, lifeguards, in relay again block by block, swim the buoy back to Seventh Street, Schoepf's old beach. It is as it should be, an athletic event on sand and in the water, along the entire beach that George Schoepf protected for so many years. (Both, courtesy OCBP.)

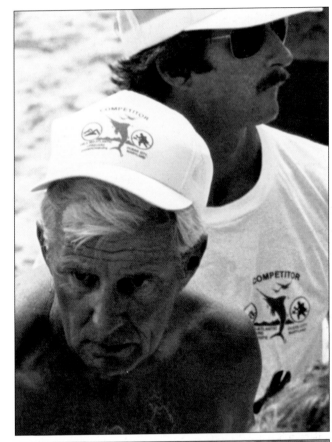

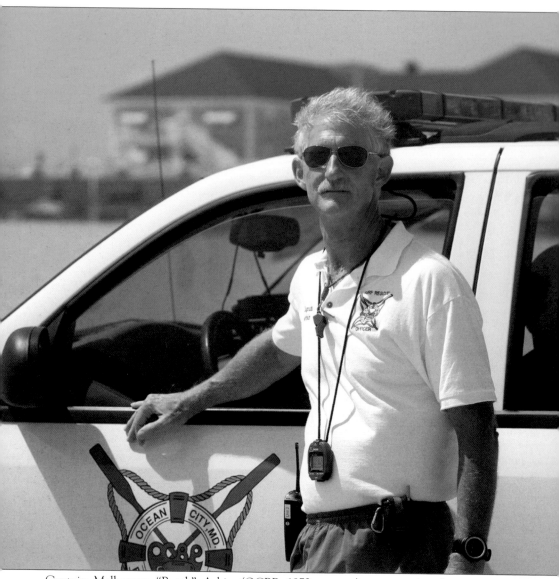

Captain Melbourne "Butch" Arbin (OCBP, 1973–present) was appointed captain in 1997. (Courtesy Swimspire.)

Four

THE MELBOURNE LEROY "BUTCH" ARBIN ERA

The leadership qualities of Melbourne Leroy "Butch" Arbin were recognized by both OCBP captains who immediately preceded him and countless public officials, fellow lifeguards, and Ocean City vacationers who witnessed his success in stewarding the patrol into the 21st century.

Butch Arbin's expertise in instructional technology and his experiences as a teacher and computer network administrator have enhanced his effectiveness in administering the beach patrol, while his personal dedication to service and outreach, to tradition, and to building character in his charges has colored his noteworthy tenure as captain. His surf rescue technicians are as active, competitive, well-trained, skilled, and physically fit as any in the history of the beach patrol. Moreover, his practices and scope of lifesaving activities have embraced missions and organizations well beyond the shores of Ocean City, including collaboration with the Coast Guard, the National Oceanic and Atmospheric Administration, and the Marine Animal Rescue Program of the National Aquarium in Baltimore. While observers note Arbin's remarkable scope of engagement with wider communities, he insists that the job hasn't changed much: "The job is still centered on an athlete with a buoy."

In his "Message from the Captain" in the *OCBP Newsletter*, Arbin wrote of "the thousands of [OCBP] members who have passed through our ranks," noting "they are all woven into the fabric." At each lifeguard alumni reunion, Arbin is inspired by "the great tradition that has been passed on to us," honoring that tradition by upholding the high standard and counseling his own patrol that "anyone can get a job . . . but you can make a difference with the Ocean City Beach Patrol." Moreover, "one doesn't really join the Beach Patrol; the Beach Patrol gets into you." He once observed, "We are family, and we change lives."

In 2019, Arbin begins his 47th year with the beach patrol. In longevity of service and impact on the youth he counsels, his has been a life of significance.

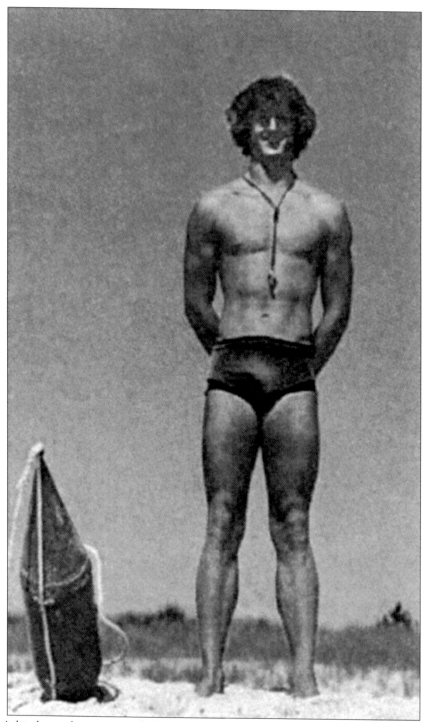

Butch Arbin began his career with the Ocean City Beach Patrol, like every other lifeguard, by passing a running, swimming, and "breaking holds" qualifying test, in his case administered in 1972 by Lt. John Swivel (OCBP 1967–1972). All positions that summer were already filled, so Arbin returned in 1973 as a rookie lifeguard. (Courtesy OCBP.)

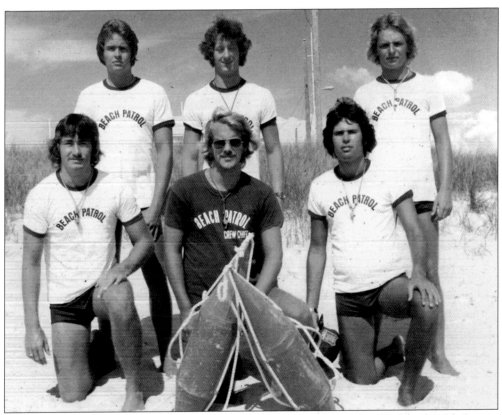

Above, in the Crew 18.5 photograph of 1974 (beaches at 138th, 140th, 143rd, and 145th Streets just below the Delaware state line), Arbin stands at center, behind crew chief Bill Baker. The crew was comprised of, from left to right, (first row) Chet Thompson, Bill Baker, and John Przylepa; (second row) Gary O'Shea, Butch Arbin, and Woody Wooden. Arbin later became crew chief at 127th Street, still north of the Carousel and developing condo row. By 1977, he was at North Division Street downtown, heading Crew 2. Promoted by Captain Craig to lieutenant in 1983, Arbin helped to define the core leadership team for Captain Schoepf by the 1990s. Below, Schoepf's 1989 officers, from left to right, are Sgts. Dave Griffith, Sean Williams, and Ward Kovaks; Capt. George Schoepf, center; and Lts. Butch Arbin, Warren Williams, and Skip Lee. (Above, photograph by Robert S. Craig; below, courtesy OCBP.)

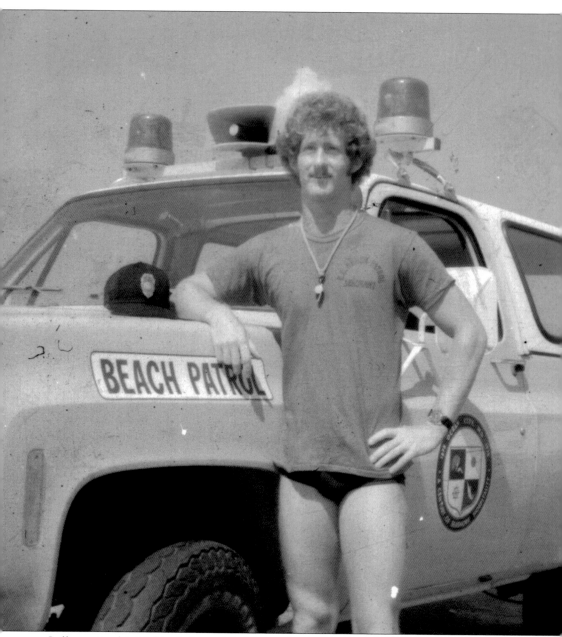

Still sporting his "Arbin Auburn Afro" hairstyle, the young lifeguard, shown here as a sergeant in 1979, appeared, like many 1970s youth of the "Age of Aquarius," more hippy than an Izod/Tab Hunter lookalike (see page 52), but Arbin nonetheless fit comfortably in the brotherhood of athletes within whose ranks he would continue to rise. (Courtesy OCBP.)

Immediately upon being appointed captain in 1997, Arbin tagged Skip Lee (above) to fill the newly created rank of first lieutenant, effectively Arbin's second-in-command. Second lieutenants included Ward Kovaks, who would become OCBP's only year-around employee beginning in September 2006, and Mike Stone. Pictured on ATVs below are, from left to right, 1st Lt. Skip Lee, Capt. Butch Arbin, and Sgt. Jamie Falcon. Falcon, a former US Navy rescue swimmer, has been employed with the OCBP since 1997 and is the beach patrol's director of training, working with Tim Uebel to coordinate the Surf Rescue Academy for rookies, put in place under the direction of George Schoepf. (Above, photograph by Robert M. Craig; below, courtesy *Inside Ocean City*, by Next Wave Studios.)

Many of the officers of the Ocean City Beach Patrol have been educators and coaches during winter months, and Captain Arbin considers OCBP outreach and education a key mission for the patrol, beginning at a very early age. Coordination with local schools and summer camps has included Camp Horizon, during which members of the beach patrol organize beach games, water safety lessons, and instruction in semaphore. Combining play with learning, a camp day at the beach initiates an awareness of water safety at a very young age. (Both, courtesy OCBP.)

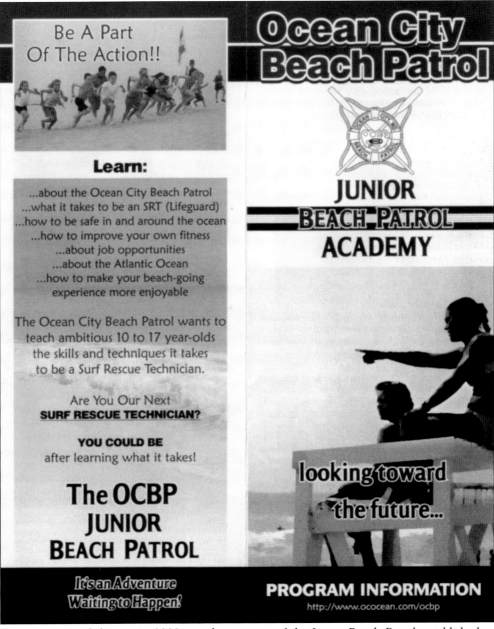

A major accomplishment in 2000 was the creation of the Junior Beach Patrol, established to provide an opportunity for youth aged 10 to 17 "to experience the training and daily routine of 'real lifeguards.'" The program has grown to serve 250 enrollees each summer in eight separate sessions organized in four levels, becoming for some participants a stepping stone toward full employment in lifesaving. (Courtesy OCBP.)

The idea of a Junior Beach Patrol organized "to instruct boys and girls in the skills and techniques of beach safety, water safety, surf rescue, and physical fitness" had been discussed for years and was reintroduced and inaugurated by Matt McGinnis (the first coordinator) and Rick Cawthern (seen here on the cover of Ocean City's *Splash* magazine). (Courtesy Town of Ocean City.)

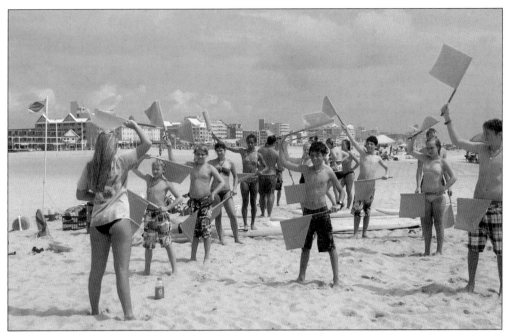

Above, among the favorite sessions of Junior Beach Patrol participants were lessons in semaphore. In 2012, a cadet program was established to retain contact with Junior Beach Patrol members with four to five years association with OCBP but not yet old enough to test for the beach patrol. Below, Ward Kovaks and Captain Arbin are with Christopher Monteferrante at the Junior Beach Patrol graduation. Monteferrante, a paid Junior Beach Patrol assistant instructor, had passed the surf rescue technician test the week before and is pictured wearing the red shirt as a probationary SRT for the next summer. (Both, courtesy OCBP.)

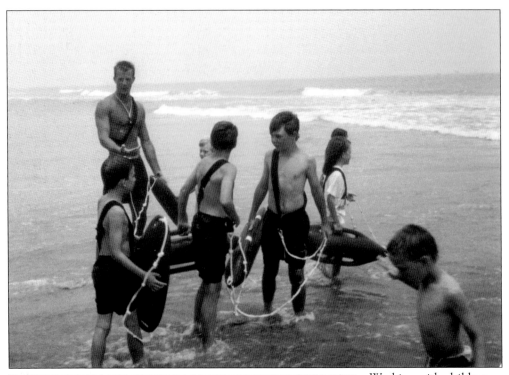

Working with children, whether at a summer camp or the beginning years of Junior Beach Patrol, provides additional training for surf rescue technicians whose job also includes the reuniting of lost children with their parents. Sgt. Harrison Fisher (OCBP 2008–present) finds "eye to eye" contact an effective skill in which to engage a little girl on the beach, whether for instructional purpose or to calm a child's fears if temporarily separated from her "lost Mum." (Both, courtesy OCBP.)

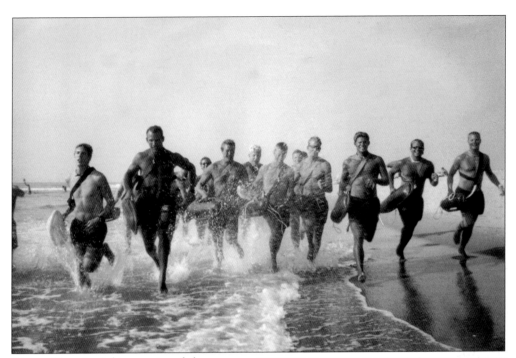

Above, Captain Arbin continued the rookie academy that had been established under Schoepf in 1991 with roots dating to 1985. Newly tested first-year guards were initially hired as probationary surf rescue technicians while an intensive course in the duties and skills of lifesaving was conducted, including mock rescues, timed runs on sand, lessons in first aid and artificial resuscitation, and semaphore testing. At right, a survival guide for probational SRTs was developed—with advice and editorial review by retired captain Craig as one of his final services to the beach patrol before his death—and further improved over the years. (Both, courtesy OCBP.)

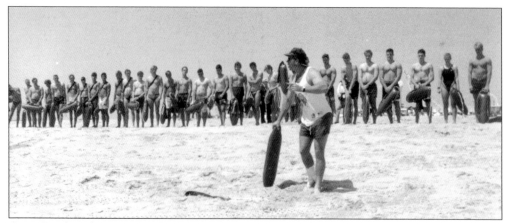

Capt. Butch Arbin, 1st Lt. Skip Lee, and other training officers conduct classes for rookies in the use of rescue buoys. The Surf Rescue Academy convenes for newly hired probationary surf rescue technicians, whose classes cover all aspects of water safety and beach patrol procedures. (Both, courtesy OCBP.)

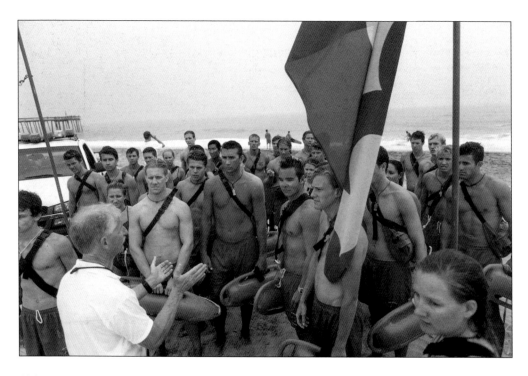

Captain Arbin congratulates rookie Steve Yardinsky on his successful completion of the Surf Rescue Academy in 2011. (Courtesy OCBP.)

Arbin's son Michael was a rookie in 2006 and returned to OCBP to serve three additional summers, from 2009 to 2011. (Courtesy OCBP.)

Returning members of the beach patrol, including established officers, are recertified annually, taking timed running and swimming tests and renewing certification in first aid and resuscitation. (Courtesy OCBP.)

Test days, workouts, and training exercises take place in calm surf as well as rough, as recorded by photographer Bill Wise on a test day in storm surf in September 2016. (Photograph by Bill Wise.)

Rescue boards are not issued as standard equipment for all Ocean City SRTs, but are part of lifeguard competitions and training. Rescue boards and Jet Skis are often seen at memorial swims, such as the annual Robert S. Craig One-Mile Swim and the Mitch Maiorana Run-Swim-Run event (see page 137), where beach patrol members monitor the progress of participating swimmers. (Above, courtesy OCBP; below, photograph by John Dunnigan.)

Additional beach patrol equipment includes inflatable motorized boats (IMBs) and Jet Skis, such as this one piloted over a breaking wave by Lt. Ward Kovaks. (Photograph by John Dunnigan.)

On other occasions, a Coast Guard boat might be brought in for advanced training or for aid in a rescue. (Both, courtesy OCBP.)

Coordination with the Maryland State Police Aviation Command includes advanced rescue training exercises, search and rescue operations, and airborne hoisting and medevac services. (Above, courtesy Sean Williams; below, courtesy OCBP.)

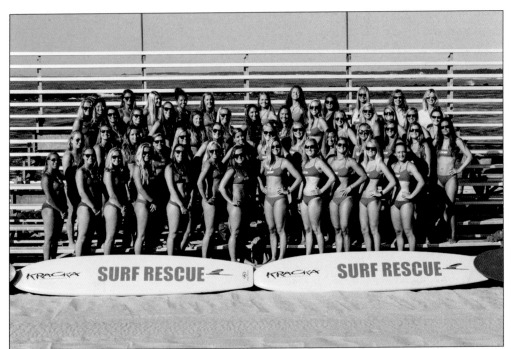

As the beach patrol continued to grow, increasing numbers of female surf rescue technicians were in evidence on Ocean City beaches, with many female SRTs participating in women's lifeguard competitions and returning home with medals and trophies. In 2018, three women on staff and 47 female SRTs and surf beach facilitators (three SBF "green suits" are seen at right) served the Ocean City Beach Patrol, including athletes from foreign countries. (Above, photograph by Tom Lurie; right, courtesy *Inside Ocean City,* by Next Wave Studios.)

Among the foreign OCBP lifeguards in recent years, male and female, have been (to name just a few), Frank Sharkey and Cilllian Read (Ireland), Carlos Ugarte (Chile), Alexandria Sabrina Osiac (Romania), Genevieve Beaulieu (Canada), and, pictured here, Marina Aleksandrova (Bulgaria). (Photograph by Jim Crowley.)

OCEAN CITY, MD

The popular television series *Baywatch* ran 242 episodes between 1989 and 2001, depicting the lifesaving adventures of fictitious Los Angeles lifeguards attired in iconic red swimsuits. For two decades during the 1960s and 1970s, Ocean City's beach patrol had adopted uniform blue swim trunks and white T-shirts, which Asst. Capt. George Schoepf had urged be changed to all red, a change he was successful in making in 1982, seven years before David Hasselhoff and Pamela Anderson institutionalized red as the uniform for bronze gods and goddesses of the beach. The *Baywatch* image clearly influenced a painting by Toni Wolf, which Eugene Kleinfeller converted to a poster, depicting Colby Nelson Phillips, an OCBP sergeant since 1999. (Courtesy OCBP and Colby Nelson Phillips.)

Demands for public relations images also occasionally resulted in the captain posing "for the cause." (Photograph by Lisa Helfert.Photography/*Maryland Life Magazine*.)

Captain Arbin's respect for tradition and his encouragement of the patrol's respect for its history is reflected in his annual staging of memorial events either begun or continued during his tenure as captain. The Robert S. Craig One-Mile Swim (1995–present) and the Mitch Maiorana Run-Swim-Run (1999–2014) were initiated by Tom Lott and Harvey Evans (OCBP 1978–1982) of the local chapter of the United States Lifesaving Association and continued on Arbin's watch. The George Schoepf Relay was initiated by Arbin in 1998. (Both, courtesy OCBP.)

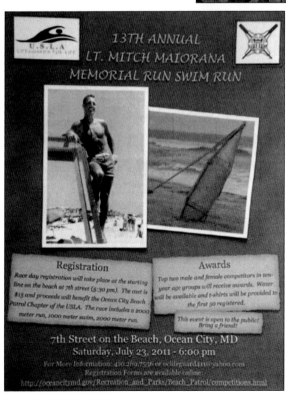

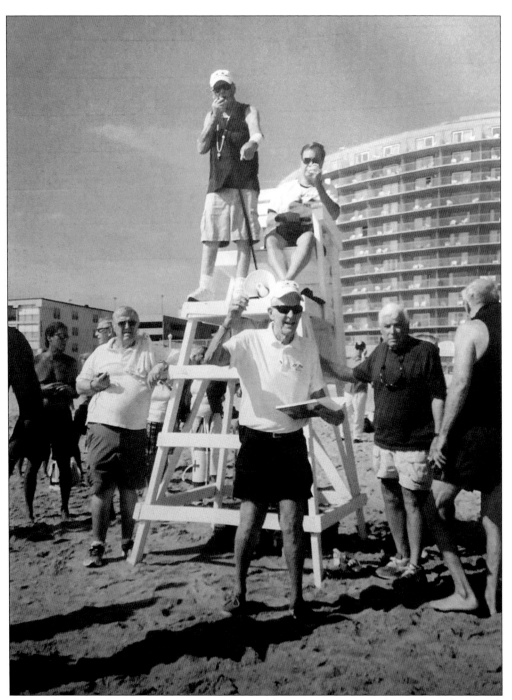

Triennial OCBP alumni reunions were organized beginning in 2000, three years after Butch Arbin became captain, with the seventh reunion planned for 2019. Gathered here in 2013 are, from left to right, Jack Chew (OCBP 1955–1957), Charlie Austin (OCBP 1949–1953), Jim Leutze (OCBP 1953–1957), and Ells Boyd (OCBP 1951–1955; back to camera), with Lucky Jordan (OCBP 1945, 1951–1955) and Mark McCleskey (OCBP 1971–1976) on the lifeguard stand. (Courtesy OCBP.)

OCBP's extraordinary success in lifesaving, its advanced skills, and its enviable safety record drew international attention in 2014 when Col. Jose Maria de Andrade, head of the 1,500-man force of lifeguards in Rio de Janeiro, Brazil, visited Ocean City to learn about the techniques and administrative practices that contribute to the beach patrol's high reputation. Gathered above are, from left to right, Ocean City Emergency Services director Joseph Theobald, Lt. Mike Stone (OCBP), Colonel Andrade, Mark McCleskey (OCBP 1971–1976), and Ocean City mayor Rick Meehan. When OCBP alumnus McCleskey learned that an average of 7,148 people drown each year in Brazil, he helped sponsor Andrade's visit. Andrade was able to observe rescue training and practice of other skills during the Surf Rescue Academy that convened during his visit. (Above, courtesy Mark McCleskey; below, photograph by John Dunnigan.)

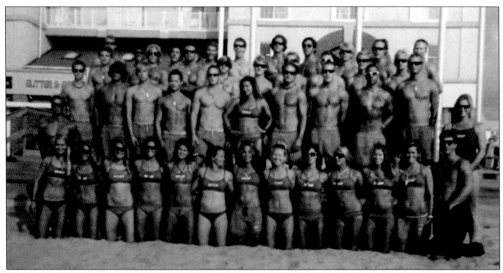

In 2005, Arbin inaugurated the OCBP website, and a Facebook page was created in October 2009. Also in 2005, the OCBP chapter of the USLA was reestablished, resulting in a resumption of OCBP participation in USLA Mid-Atlantic Regional (MAR) and USLA National Lifeguard Championships after several years of inactivity. Ocean City was the MAR champion team in 2010, 2011, 2017, and 2018, with individual successes throughout the period. Pictured here are the 2010 (above) and 2018 (below) championship teams. (Both, courtesy OCBP.)

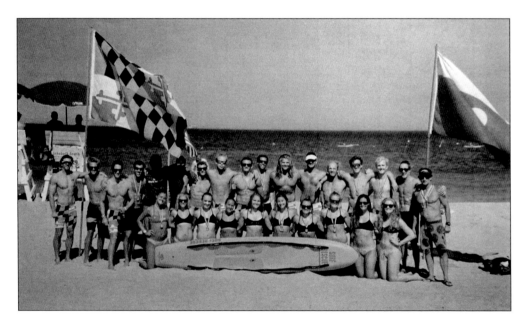

In 2000, the Ocean City Development Corporation was established and immediately set about restoring an 1897 boardinghouse called Tarry-A-While to be used for OCDC headquarters and housing for 15 members of the beach patrol. The facility opened in 2007. (Courtesy Museum of Fine Arts, Boston.)

Eight years later, ground was broken for a new Beach Patrol headquarters, designed by the Becker Morgan Group of Salisbury, Maryland, and built by Gillis-Gilkerson, construction manager. As early as 1957, Captain Craig had called for a dedicated headquarters for OCBP; 58 years later, the OCBP headquarters was finally opened, a major accomplishment in 2015 by the Arbin administration. (Courtesy OCBP.)

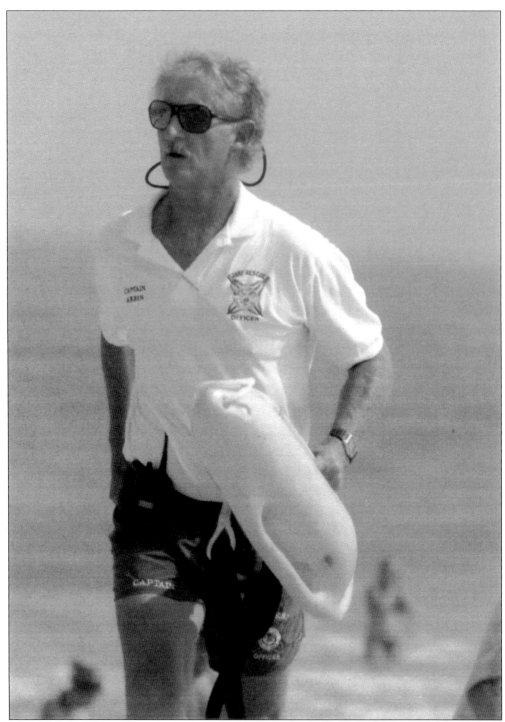

While Captain Arbin continually described his job as a great adventure while humbly declaring the full team, not the captain, was "number one," he too is "an athlete with a buoy," and he has remained an embodiment of the best practices—and of effective leadership—in lifesaving. (Courtesy OCBP.)

With a mission embracing prevention and interdiction but also education, one of the key members of Arbin's team has been Kristin Joson, OCBP's public education coordinator and photographer. Many of Joson's photographs appear in this volume. (Courtesy OCBP.)

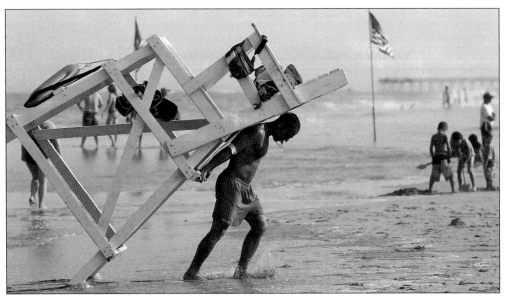

At the end of the day, the lifeguard stand is dragged above the high tide line, and the SRT blows his whistle to signal "off duty." Then, as Ward Kovaks composed in the patrol's motto, the public is asked to come out of the ocean and "Keep your feet in the sand until the lifeguard's in the stand!" The beach will be crowded and well-guarded again tomorrow. (Above, photograph by John Dunnigan; below, photograph by Allen Sklar.)

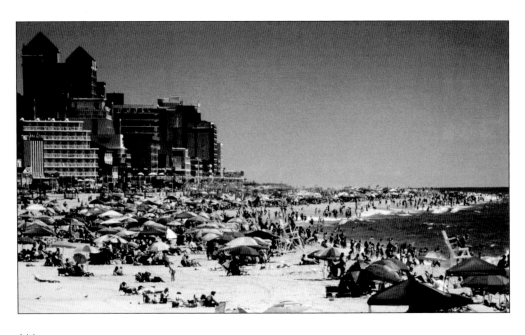

Like the victorious coach at the top of his game, Arbin is a good sport, and willing to take a dose of chilled water for the cause, so long as it is salt water. It is a sign of camaraderie and respect, expressed by men and women of good character who can still enjoy a bit of mischief occasionally. (Courtesy *Inside Ocean City*, by Next Wave Studios.)

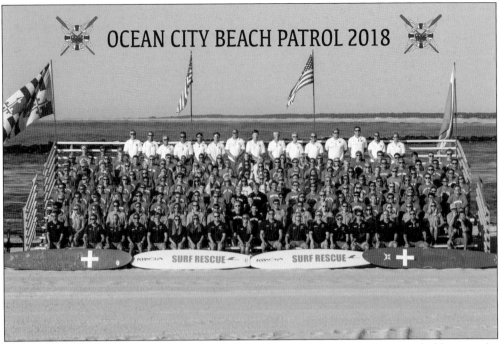

Pictured above are members of Arbin's 2018 beach patrol—ready, willing, and able to make their own history as master surf rescue technicians, or as their OCBP predecessors (the alumni "legends of lifesaving") would call them, Maryland's open water lifeguards *par excellence*. The beach patrol patch below dates from the post–World War II era. (Above, photograph by Tom Lurie; below, courtesy the Robert S. Craig collection.)

Only God saves more lives than the O.C. Beach Patrol

Bumper stickers and patches convey various sympathies of professional lifeguards, including a slogan adopted by the United States Lifesaving Association, "Lifeguards for Life," as well as a hubristic claim from the 1960s, "Only God saves more lives than the O.C. Beach Patrol." (Both, courtesy the Robert S. Craig collection,)

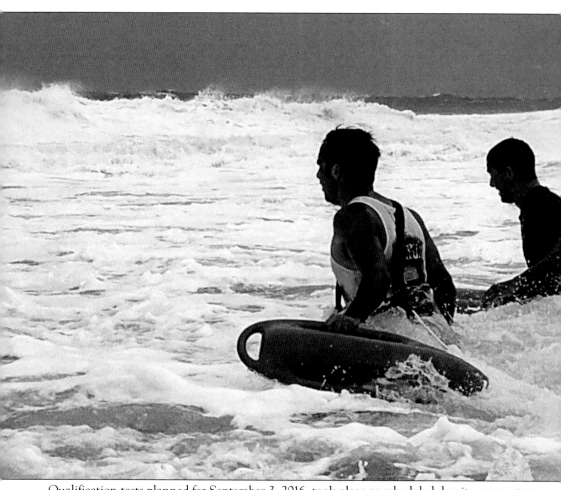

Qualification tests planned for September 3, 2016, took place as scheduled despite severe storm surf conditions, a challenge that offered a reality check for any lifeguard hopefuls who thought the job to be one of merely sunbathing all summer on a lifeguard stand. (Photograph by Bill Wise.)

Five

LEGACY HERITAGE TRADITION

It remains an ambition of many young men and women to become an Ocean City lifeguard. It has always been *the* summer job at the ocean resort, presumed to be the glory job, whereas its full dimensions are soon disclosed to all who make the grade. "It was a childhood dream," lst Lt. Skip Lee once told a reporter. "Why do you put your life at risk?" lifeguards are asked, especially when rip currents are rampant, waves are high, and the sea is raging. With a level of confidence nurtured by familiarity with the ocean and cultivated by training and practice, OCBP members, while never foolish enough to dismiss the risk, are disciplined and equipped to meet it. Theresa Humphrey, in "Ball Honors OC Lifeguard Chief Capt. Bob Craig," quoted Captain Craig at the end of his active career in lifesaving: "I've never been where I wasn't quite sure. Never. If I've ever been out there, there's never been a doubt in my mind that I wouldn't get them to shore. I can say that unequivocally."

Throughout the years, young men and women reapply to work on the patrol. Currently, six members of the patrol have 30 or more years of affiliation, and a recent tabulation recorded that over 40 percent of OCBP staff have five years or more service on the patrol. When Captain Arbin was asked "What keeps them coming back?" he remarked, "I believe I have discovered the answer . . . a true and deep feeling of significance . . . we offer an opportunity for 'significance.' "

Legacy, heritage, and tradition express similar ideas about the past and its relationship to the future. When there are 357 rescues in a single day, as occurred in Ocean City on August 29, 2015, many individuals have been given back their almost-lost futures by the actions of a surf rescue technician. Lifesaving is a legacy. Today's SRTs are a fine-tuned product of OCBP's lifesaving traditions. Each rescue is a legacy for the future.

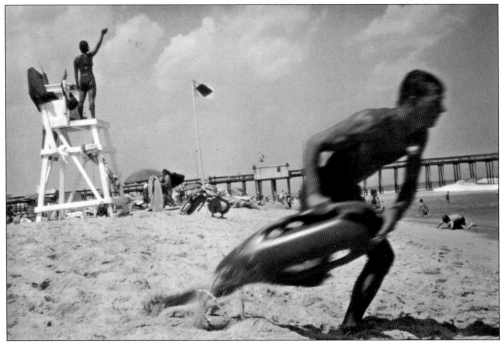

Memories are part of the legacy of the Ocean City Beach Patrol, and they can vary from what George Schoepf called "days of boredom [to] days of trauma," but most memorable are those more dramatic rescues with fellow guards always covering your back, a "pull" sometimes involving over a half-dozen lifeguards in a coordinated effort with flanking guards "shifting" in sequence over multiple blocks in order to keep the rescuing guards' beaches covered during the event. (Both, courtesy OCBP.)

Steve Nelson illustrates the stereotypical "benefits" of being a lifeguard. However, as one lifeguard recalled of Captains Craig and Schoepf: they "expected us to maintain beach safety to the utmost and not be distracted from our duties," so "if they caught us with too many chicks around our lifeguard stand, we'd get a dose of 'The School of Hard Knocks'—i.e., a real good blistering!" (Courtesy the Robert S. Craig collection.)

Wayne Brubaker continues to watch the water as he opens a bandage for a little girl needing minor first aid. Young women 10 years older sometimes employed similar ploys to meet the lifeguard ("Hey, Mr. Lifeguard, will you fix my boo boo?"), as the author recalls when one day he rescued the same bikini-clad "real looker" three times from the same small rip current. (Courtesy Wayne "Bru" Brubaker)

Among the traditions of OCBP, dating from the sponsoring of lifeguard dances in the early years to reunions in later years, are fraternizing, fun, and a little after-hours tomfoolery. Although the high standard for presenting the "proper" appearance and conduct on or off the job was a mandate dating to Captain Craig's era, lifeguards occasionally engaged in harmless silliness as in this c. 1990 pose of nine lifeguards of the "whacko crew" (left), from left to right, (on the sand) Will Kapinos, Kurt Nysmith, Mike Lambert, and Dave Barnhart; (on the stand) Bill Battle, Brian "Squirrel" Park, Mike Perry, Dave Stechert, and Charlie Schoenberger. Below is a 1989 image of off-duty officers, from left to right, Ward Kovaks, Sean Williams, Dave Griffith, and Skip Lee. (Both, courtesy Sean Williams.)

On the other hand, the job was the most serious commitment of these young people's lives, and OCBP lifeguards are trained to handle real emergencies, ranging from heart attacks to back and neck injuries (sustained usually as the result of rough surf and breaking waves). Moreover, an uninterrupted day of multiple rescues from rip currents can be a challenge of endurance. Above, the use of surfboards, skim boards, and boogie boards not infrequently leads to wipeouts that can result in injury. Below is a training session of extraction from the surf of an individual with a back or neck injury. (Above, photograph by Robert Banach; below, courtesy OCBP.)

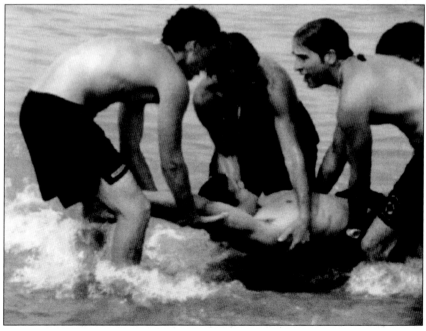

After a rescue, lifeguards dismiss any claim of heroics by asserting, "I'm just doing my job." One former OCBP member wrote Captain Craig about a rescue he recalled from the 1970s. Two decades after the event, he was reading a book sent to him at the time of the rescue by the woman he had pulled from the surf. Inside the back cover (he had not earlier noticed it) was the inscription "Dear George. Thanks for 'just doing your job' on July 2, 1973. You saved my life!" In turn, George wrote to his captain: "So many pulls, and so little memory—only kept track of the numbers. But at least, if nothing else, I have one credential to present at the gates of Heaven." (Above, courtesy OCBP; below, courtesy *Inside Ocean City* by Next Wave Studios.)

Information about water safety, passed on to the public and to future generations, is part of the legacy of the Ocean City Beach Patrol. The patrol's leaders have historically been educators, benefiting from their ability to dovetail academic year obligations with a full-time summer job saving lives and training others to do so, filling in their school's vacation months. Not only are the officers skilled trainers and teachers, but individual OCBP members are articulate ambassadors in the cause of beach safety, lifesaving, and public awareness. The lifeguard as educator is in evidence in SRTs' periodic spontaneous beach education sessions (above) as well as scheduled public presentations, such as offered by Sgt. Tim Uebel at the lifesaving museum (below). (Above, courtesy *Inside Ocean City*, by Next Wave Studios; below, courtesy OCBP.)

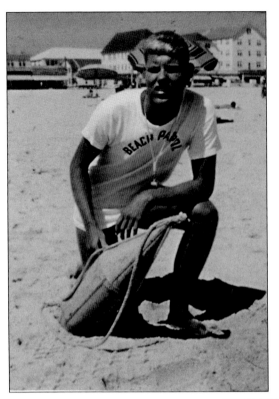

"Lifeguards for Life" (see page 147) is an acknowledged legacy of service of the Ocean City Beach Patrol. It reflects the ingrained dedication of SRTs to their summer job: few can return to the beach as vacationers in later life without scanning the water and noticing the changed color of a running rip current or eavesdropping on a semaphore message, while his own young offspring ask about the flashing red flags, "What's he saying, Daddy?" Some alumni return periodically to lend the beach patrol a helping hand. Notable has been Bill Wise (OCBP 1962–1965, 1968–present), a Vietnam veteran and consummate photographer, returning "home" each summer to volunteer, wherever needed, for the organization to which he has always been loyal. Men like Bill Wise are part of the legacy of OCBP. (Both, courtesy OCBP.)

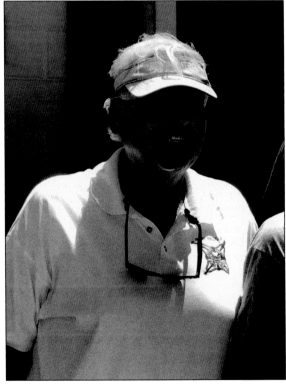

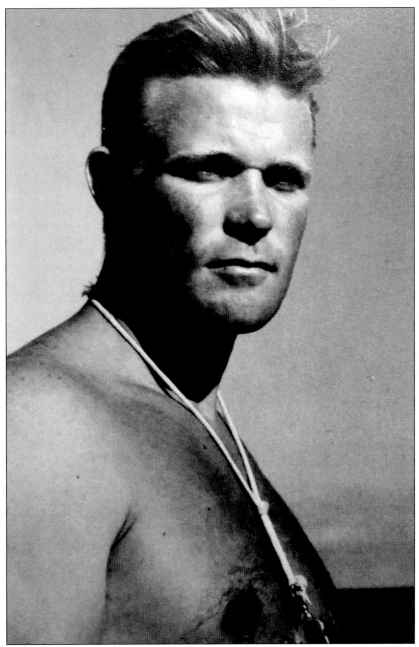

The names of certain OCBP lifeguards will remain forever etched in stone, but none more deservedly, perhaps, than the iconic Lucky Jordan. During the early 1950s, Jordan guarded Maryland's beach in the summer and Fort Lauderdale, Florida's, beach in the winter. Throughout his life he was a preeminent waterman, served Fort Lauderdale as aquatic supervisor (teaching, coaching, overseeing new swimming pool plans), and was significantly involved in the establishment of the International Swimming Hall of Fame. He credits OCBP as the catalyst for a career in lifesaving and water activities, and he frequently returned to his roots on Ocean City's beach. Humble yet storied, "Lucky" remains in OCBP's collective memory as an embodiment of the best traditions of lifesaving, whose legacy is a part of us all. (Courtesy OCBP.)

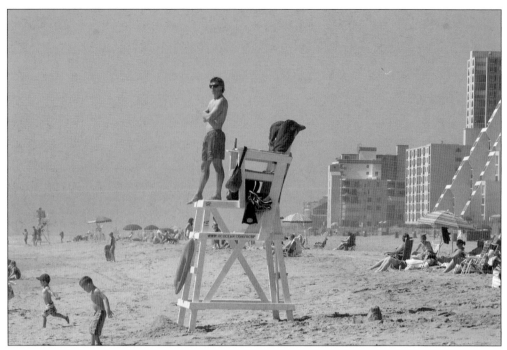

When a town with a winter population of 7,102 welcomes 345,000 vacationers on a summer weekend, many wonder how the lifeguards can watch out for so many swimmers. Perhaps OCBP's greatest legacy is the organization's enviable record of safety achieved by learned techniques and best practices by which SRTs adopt procedures that anticipate and that are preventative. Captain Craig used to tell his lifeguards "you should be halfway to the struggling swimmers before they realize they are in trouble." A studied habit of preparation for action is a legacy that continues to serve today's surf rescue technicians, who remain professionals in the art of recognizing the potential of a developing crisis in the water. Above, in 2015, Asst. Crew Chief Robert Leszczynski watches from his lifeguard stand, ready to leap to the rescue. (Both, courtesy OCBP.)

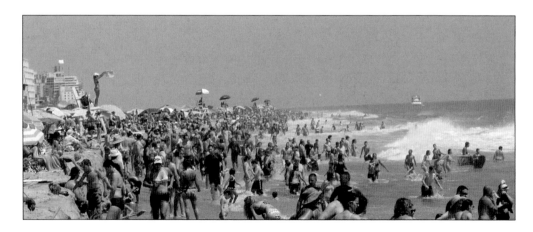

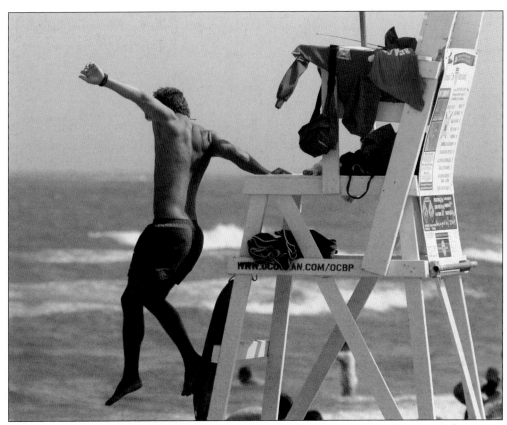

At the end of the day, long shadows of oceanfront buildings begin to reach toward the water's edge, promenaders stroll the boardwalk, and the lifeguard carries his buoy across the empty beach, off duty until another day. It is a ritual that embodies Captain Arbin's observation, earlier quoted, that in the end, the job of each member of Maryland's Ocean City Beach Patrol is that of an athlete with a buoy. (Above, photograph by dbking; below, courtesy OCBP.)

DISCOVER THOUSANDS OF LOCAL HISTORY BOOKS
FEATURING MILLIONS OF VINTAGE IMAGES

Arcadia Publishing, the leading local history publisher in the United States, is committed to making history accessible and meaningful through publishing books that celebrate and preserve the heritage of America's people and places.

Find more books like this at
www.arcadiapublishing.com

Search for your hometown history, your old stomping grounds, and even your favorite sports team.

Consistent with our mission to preserve history on a local level, this book was printed in South Carolina on American-made paper and manufactured entirely in the United States. Products carrying the accredited Forest Stewardship Council (FSC) label are printed on 100 percent FSC-certified paper.

MADE IN THE USA